IMAGES
of America

MAYNARD
MASSACHUSETTS

Cover: One of the first automobiles in Maynard was a red Ford owned by Charles H. Persons, about 1900. In the front seat is Fred Persons, the chauffeur. In the back seat are Clarence Bodfish and Charles Persons. In the background to the right is the Maynard Block Building (later Masonic Building). In the background to the left is Amory Maynard II's residence at what is now Maynard Center.

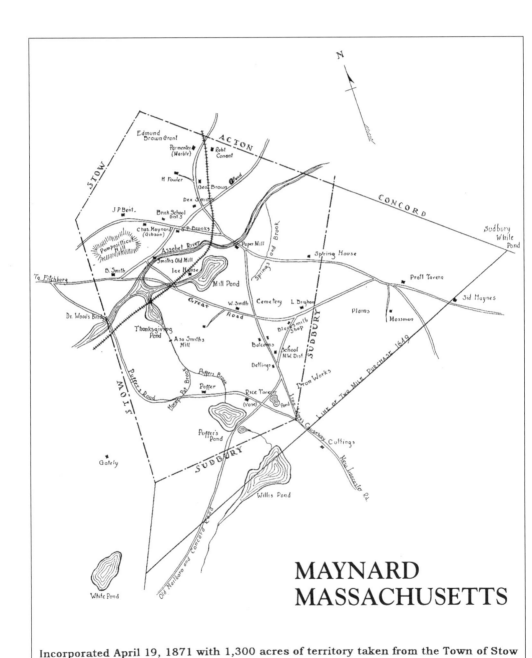

MAYNARD
MASSACHUSETTS

Incorporated April 19, 1871 with 1,300 acres of territory taken from the Town of Stow and 1,900 acres of territory taken from the north westerly part of the Town of Sudbury.

IMAGES
of America

MAYNARD
MASSACHUSETTS

Paul Boothroyd and Lewis Halprin

ARCADIA

Published by Arcadia Publishing,
an imprint of Tempus Publishing, Inc.
2 Cumberland Street
Charleston, SC 29401

Printed in Great Britain.

Library of Congress Catalog Card Number: 99-63936

For all general information contact Arcadia Publishing at:
Telephone 843-853-2070
Fax 843-853-0044
E-Mail arcadia@charleston.net

For customer service and orders:
Toll-Free 1-888-313-BOOK

Visit us on the internet at http://www.arcadiaimages.com

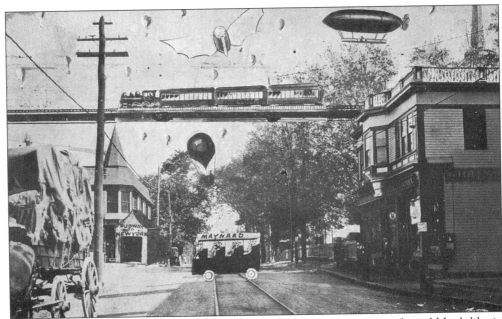

MAYNARD IN THE FUTURE. This postcard from 1909 shows what Maynard would look like in the 1990s. Notice all of the "old" technology; horse-and-wagon, steam engine railroad locomotive, telephone polls, hot air balloons, etc.

CONTENTS

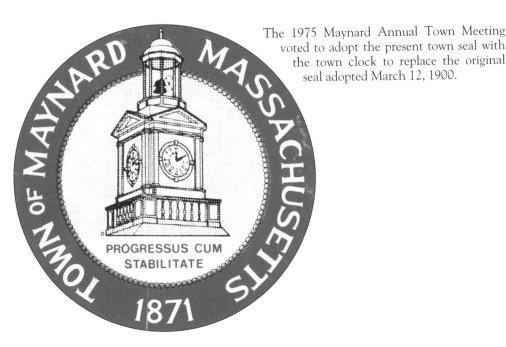

The 1975 Maynard Annual Town Meeting voted to adopt the present town seal with the town clock to replace the original seal adopted March 12, 1900.

Acknowledgments

Paul Boothroyd—As the archivist of the Maynard Historical Society, I oversee approximately 2,000 images. From these, I had the very difficult task of choosing the 230 images that appear in this book. I wanted to cover all of Maynard's image history with only minimal duplication of images previously published (Gutteridge's 1921 book, *A Brief History of Maynard*; Maynard Historical Society's 1971 book, *A History of Maynard*; Maynard Historical Society's 1996 book, *A Maynard Sampler*; and a soon to be published Arcadia book, *Assabet Mills*). I hope my selections succeed in showing you how the present Maynard came to be.

Lewis Halprin—The Town of Maynard is an amazingly compact town squeezed in between three much larger towns and firmly anchored to a portion of the Assabet River. Within this relatively tiny space, they built the largest woolen mill in New England and later converted it into the largest minicomputer company in the world. They fueled it all by a rich ethnic mix of hard-working people. They built churches of all denominations, provided big city utilities, established good, active schools, and formed a responsible government largely made up of unpaid citizens. I am pleased that my involvement with the pictures and stories in this book has given me the opportunity to see what happens when hard-working people are mixed with industrial and commercial opportunity.

Image Sources—Most of the images are from the Maynard Historical Society archives. Those that are from other sources are so indicated at the end of the picture's caption. The following is a summary of those image credits:

[Case]——Ralph Case.
[Gruber]——Bert Gruber.
[France]——David France.
[Fraser]——Arlene Fraser.
[Malcolm]——John Malcolm.

[Micclche]——Alphonse Micclche.
[Murphy]——William Murphy.
[Rod & Gun]——Maynard Rod & Gun Club.
[Sarvela]——Edwin "Sam" Sarvela.

INTRODUCTION

The Town of Maynard is the area's youngest community, incorporated in 1871. Previously, the town was known as Assabet Village, nestled in a valley where the towns of Stow and Sudbury were divided by the Assabet River.

In 1869, the people of Assabet Village began to seriously consider incorporation as they were far from the public houses of Stow or Sudbury, and there was no speedy means of conveyance to either place. The village also needed amenities such as streetlights, sidewalks, police, and a more effective school system as well as regulations adapted to their population and business types. The towns of Stow and Sudbury were more inclined to be farming districts, while Assabet Village was growing into a manufacturing community.

There was a petition signed by Henry Fowler and other prominent citizens that was presented to the legislature. There was strong opposition from Sudbury, which had appointed a committee to prevent legislative approval. However, Stow did not object. The state granted and signed Maynard's charter on April 19, 1871. The unanimously voted name, Maynard, was in honor of the man who developed the community from a sparsely settled farming district in 1846 to the lively manufacturing town of 1871. Born in 1804, Amory Maynard was running his own saw mill business at the age of 16. In the 1840s, he went into partnership with a carpet manufacturer for whom he had done contracting. They dammed the Assabet and diverted water into a mill pond to provide power for a new mill, which opened in 1847 and produced yarn and carpets. Maynard's first town meeting was called on Monday, April 27, 1871. Recorded statistics have the town with 321 houses, a population of 1,820, and a land area of 5.7 square miles, making Maynard the third-smallest town in the commonwealth.

Prior to European settlement, Maynard was seasonally inhabited by Native Americans. The area was called Pompasittakutt after a beautiful hill now commonly referred to as Summer Hill. It was reported that in 1676, Native Americans gathered atop this hill for a pow wow to decide which town would be attacked, Concord or Sudbury. Sudbury was chosen, and the event was recorded in history as "The Sudbury Massacre."

Originally, Maynard's valuation was set at $1,002,000. By 1893, old-time newspapers reported that figure at $2,074,416 and considered Maynard to be one of the wealthiest towns in the state. The reason for this was the Assabet Manufacturing Company, the nation's largest all-wool manufacturer employing 1,000 hands. That number grew with an influx of Finnish, Polish, Italian, Irish, and other immigrants. Each brought their culture and way of life to make Maynard a truly diverse American town.

Within Maynard, there is a saying: "As the mill goes, so goes the town." As the mill grew, the town grew in proportion and became a thriving business community. Whenever the mill had layoffs, the town also suffered and declined.

This book focuses on Maynard from its birth as a village and then a town, through the ups and downs of the centrally significant mill, until the rise of Digital. Most of all, it is for the enjoyment of the old timers and the townies, allowing them to reminisce about the past.

There are photographs of people, their homes, and everyday businesses carefully selected from the Maynard Historical Society's large collection and from private individuals. Most have never been published before. We hope that you enjoy what the Maynard Historical Society has assembled here.

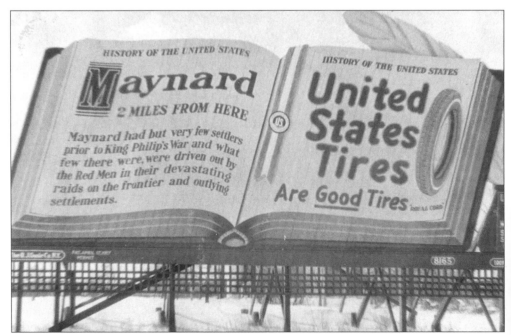

HISTORIC BILLBOARD. This billboard was located at 9 Acre Corner in Sudbury, on Route 117. The picture was taken by Robert Sheridan in 1935.

One
MILLS

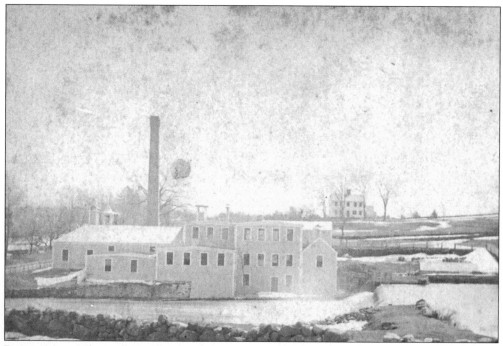

PAPER MILL. The mill was located at the corner of Waltham & Parker Streets, where the United Cooperative service station was located. Built in 1820 by William May, it was sold to John Sawyer and then later to William Parker. In 1831, it became the Fourdrinier Paper Co., Inc. That company operated until 1882, when the Assabet Mfg. Co. bought it in 1893 for their water rights. The water rights were never used. The building was destroyed by fire on May 14, 1894. Its chimney remained, but was razed on Aug. 14, 1914. Traces of the dam used to supply waterpower to the mill may still be seen.

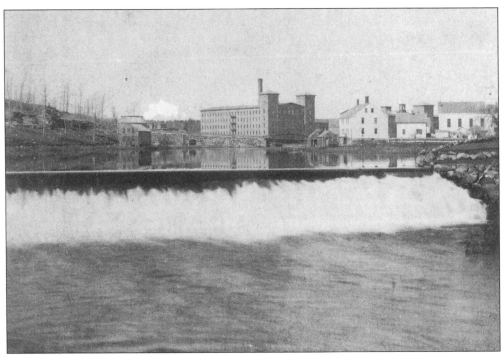

PAPER MILL DAM. Until 1927, this dam was located south of where the Assabet River runs under the so-called paper mill bridge. Both the dam and the bridge were washed out in November 1927. The bridge was replaced.

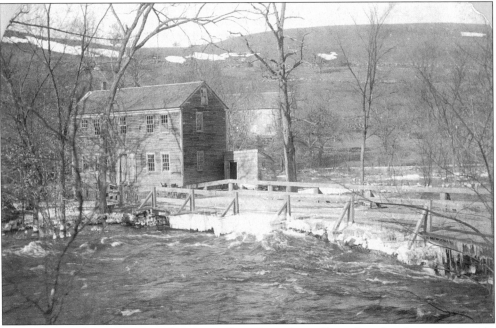

GRIST MILL. This was a sawmill, a gristmill, and a cider mill combined and was run by Asa Smith. It also was known as a place to go in order to hear the news or local gossip. It was called Jewell's Mill, and it made spindles and other machinery used by the textile mills.

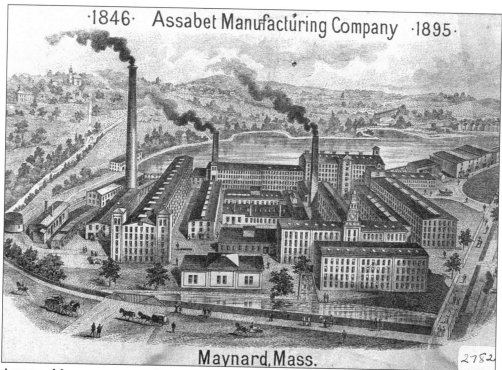

·1846· Assabet Manufacturing Company ·1895·

Maynard, Mass.

2782

ASSABET MANUFACTURING COMPANY. A joint partnership was formed between W.H. Knight and Amory Maynard for carrying on the carpet business in what is now known as Maynard.

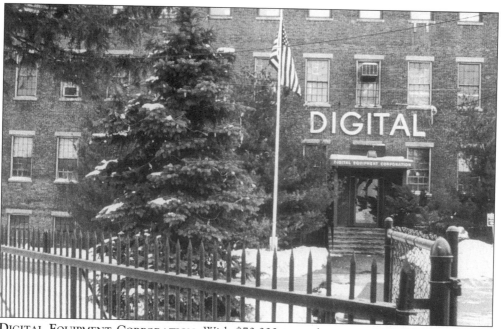

DIGITAL

DIGITAL EQUIPMENT CORPORATION. With $70,000 in seed money and 8,600 square feet of space at Maynard Industries #12 Mill building, three engineers launched Digital Equipment Corporation in 1957.

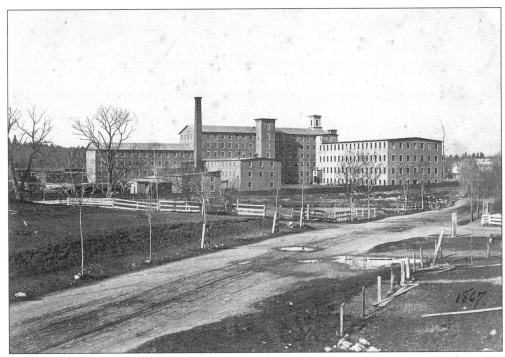

ASSABET MILLS IN 1867. This view of the mills was taken from Walnut Street. At that time, Walnut Street was on the south side of the river and ran from Main Street to Thompson Street. In 1872, the street was relocated on the north side of the river, running from Main to Parker Street, and an iron bridge was built across the river on Walnut Street.

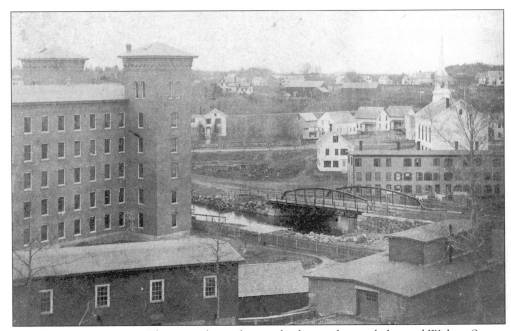

ASSABET MILLS IN 1872. This view shows the iron bridge on the newly located Walnut Street. Note that the Maynard block (Masonic Building) had not yet been built.

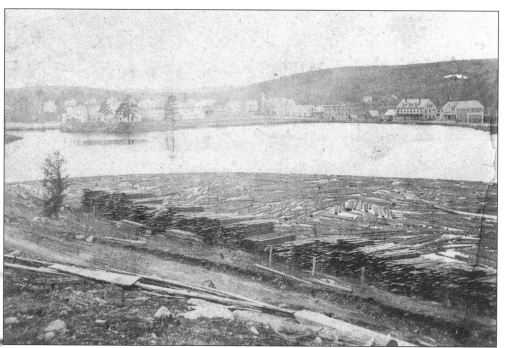

MILL POND. This pond was built for Amory Maynard by Artemous Whitney on land formerly owned by Artemous Whitney. The logs floating in the pond are waiting to be milled for new mill construction and were kept in the water in order to prevent them from shrinking, drying out, or becoming infested with insects.

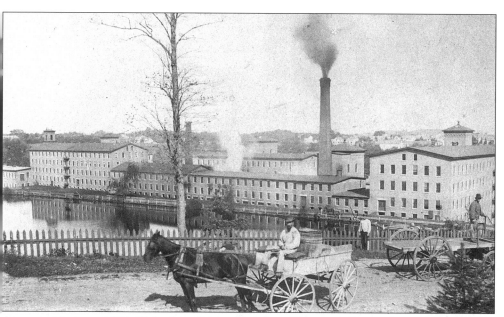

ASSABET MILLS IN 1881. This view of the mills is from Thompson Street. Amory Maynard, the founder of the mills complex, continued as the mills' agent until failing health in 1885 necessitated relinquishing that position to his son Lorenzo.

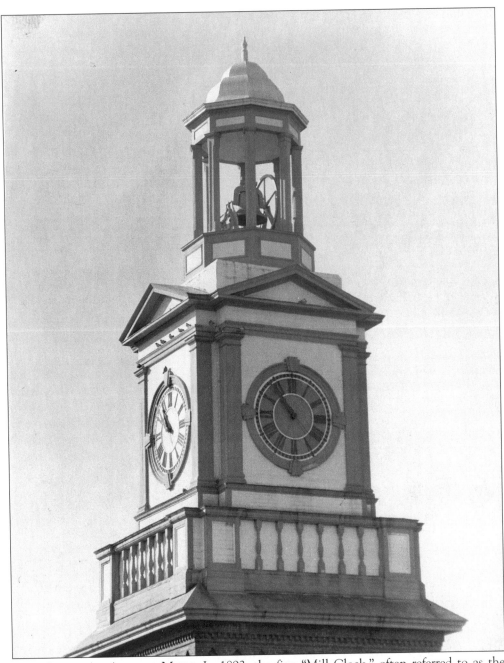

MILL CLOCK AT ASSABET MILLS. In 1892, the fine "Mill Clock," often referred to as the "Town Clock," was given by Lorenzo Maynard and placed in position in the fall of that year in the tower erected by the Assabet Manufacturing Company. It was used on the reverse side of the medal for the Centennial in 1971, and in 1975, it was adopted as the Town Seal.

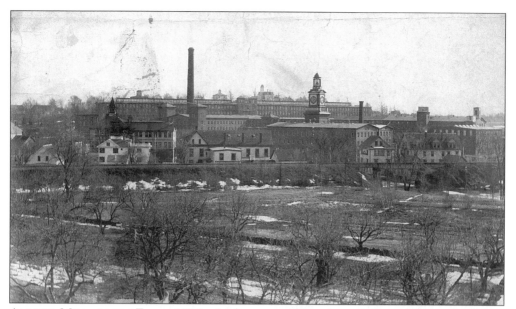

ASSABET MILLS IN THE EARLY 1900S. In the center of the picture is the railroad embankment and bridge, which was completely removed in 1980 as part of the revitalization of the downtown area. In the far background behind the No. 5 mill, from left to right, one can see the tower on the home of Lorenzo Maynard, the tank house for the mills, and the upper part of Amory Maynard's mansion.

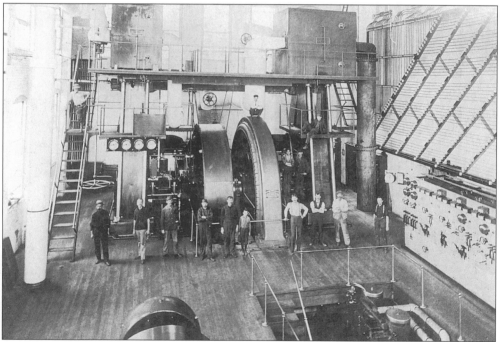

POWER HOUSE IN 1902. Since 1889, the mill had its own illuminating gas works, which were replaced later by more efficient electric lighting and electric motors. The electrical power was generated at the plant, and the quantity was enough to enable it to provide electricity to the town of Maynard.

WEAVE ROOM. These are four of the many workers who worked in the weave room. In the front row are W. Smith and H. Maynard, and in the rear row are W. Denniston and J. Brayden.

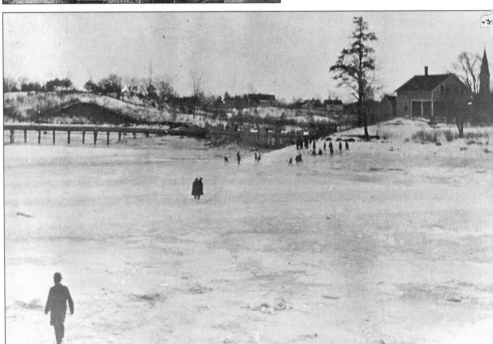

EMPTY MILL POND. These people are enjoying the opportunity to walk on the bottom of the mill pond (1916–1919), which was drained at that time in preparation for new building construction.

Two
HOUSES

THE CALVIN WHITNEY HOUSE. Daniel Conant, who lived in the Calvin Whitney house, was the first man wounded at the Concord fight, April 19, 1775, and was later sergeant at Bennington, Vermont, when General Burgoyne surrendered. The house was located on property currently owned by the Maynard Country Club.

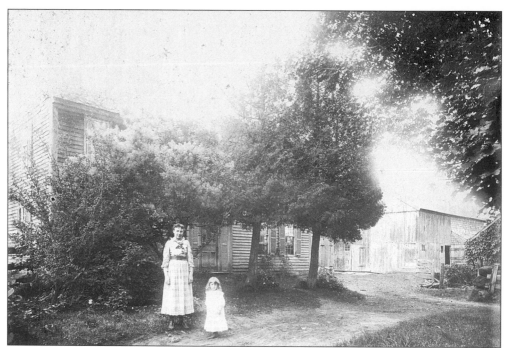

GEORGE R. BROWN HOUSE. The Brown house and farm consisted of 200 acres. The land, since then, has been subdivided. Alice Brown (Howe) and her mother, Mary Elizabeth Whitman, are shown in front of the house on Acton Street.

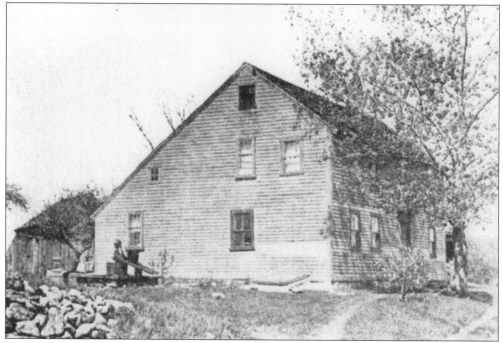

PUFFER HOUSE. The Puffer house was formerly the Wedge-Pratt Farm. It was sold to Jabez Puffer in 1743. He was the first of the Puffer family to settle in Sudbury. The house was located on Puffer Road, in what is known as the Ammo Dump.

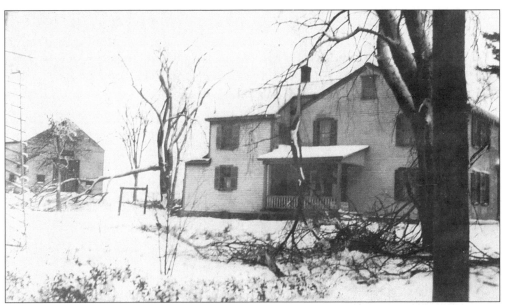

SILAS P. BROOKS HOUSE. The Silas Brooks house, built about 1764, is one of the oldest existing houses in Maynard. It is located at the corner of Summer Lane (which was also called "Lover's Lane"). The barn at the rear of the house is long gone. (Case.)

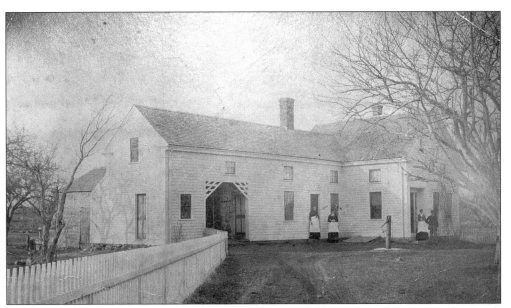

DEXTER SMITH HOUSE. This house was built on Concord Street in the late 1700s. The Smith family owned most of the land then known as Assabet Village (now Maynard). The house still exists today.

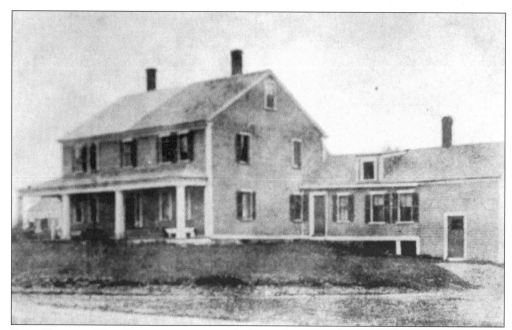

RICE TAVERN. Rice Tavern was a general place of meeting for the early settlers, and many matters of importance to the "district" were discussed and settled here. It was purchased from Benjamin Crane of Stow in 1685. For 100 years, it was used as a tavern. Since 1815, it had been owned by Jonathan Vose and used as a farmhouse, until it was destroyed by the government in the 1950s.

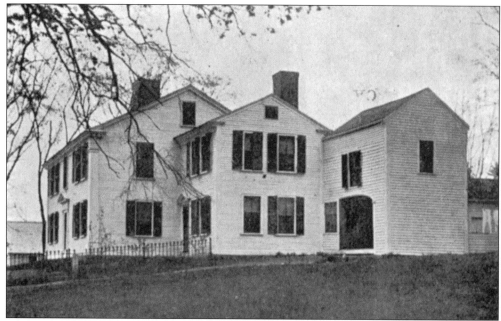

LEVI SMITH HOUSE. Levi Smith was the first to own the farm, and in 1816, it was used as a tavern when Great Road was opened. It was one of several taverns along the way between Boston and Fitchburg to accommodate travelers. Later, it became the Eveleth estate, and then the Thompson estate.

HAMAN SMITH HOUSE. The Haman Smith house is located on Great Road and is also known as the Case house. Haman owned much land in Assabet Village and gave each of his four sons a farm.

WILLIAM SMITH HOUSE. The William Smith house was located on Great Road and was purchased by the town of Maynard on May 1, 1892, for the care of the poor. This was an early form of welfare, and the house received the name "The Poor Farm." In 1898, as many as 1,664 tramps were lodged here.

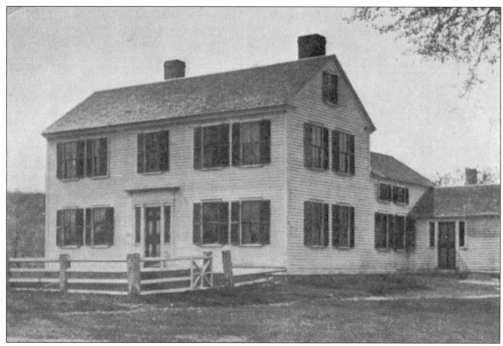

LOUIS BRIGHAM HOUSE. The old homestead where Abijab Brigham formerly lived was 10 rods from the present house. There was a blacksmith shop on the point across the way.

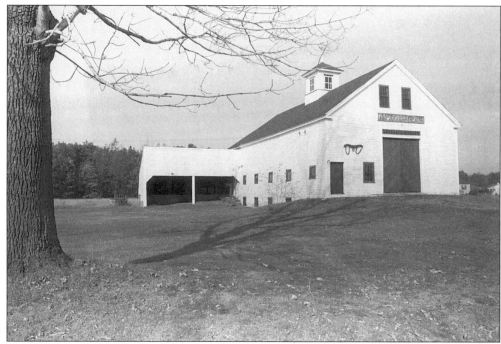

ASPARAGUS FARM. This old barn on Great Road is one of the few remaining early New England barns left in Maynard. Its last farming use was as an asparagus farm by the Saunders family. The barn is slated to be demolished in the near future.

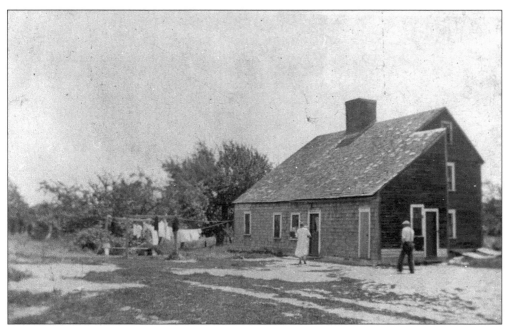

Jim Haynes House on Puffer Road. This was one of many homes demolished by the government after it was taken by eminent domain in 1942 to be used as an ammunition dump during World War II. The last owners of the house were the Sarvela family.

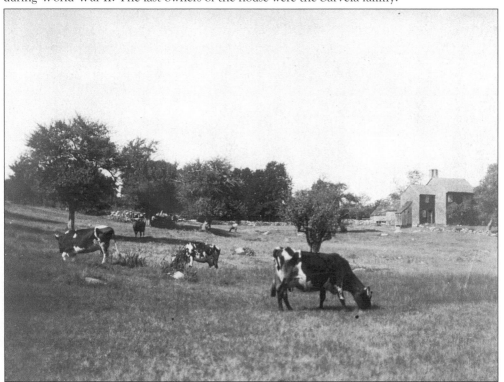

Cows Along Puffer Road. These cows are grazing on the Sarvela farm. The property was taken by eminent domain by the government in 1942 for a WW II ammunition dump.

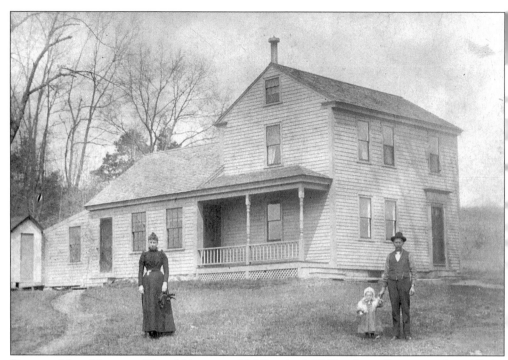

POWDER MILL VILLAGE. The old house at 106 Powder Mill Road is still in use today. All the land along the river was considered good farmland.

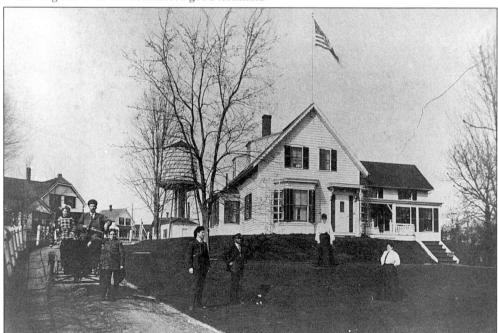

DR. F.U. RICH HOUSE. This house and farm was located on the site of the present Fowler Middle School on Summer Street. The town bought the property in 1915 to build a new high school, and the house was moved to Florida Road. It is now a two-family house owned by the Sarvela family.

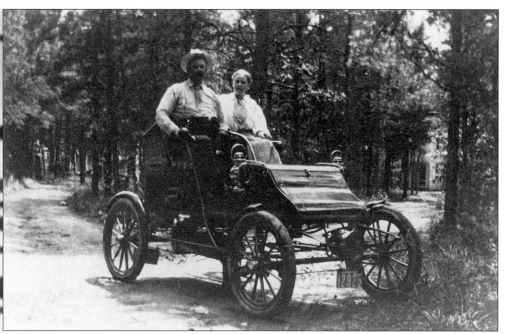

FIRST AUTOMOBILE IN MAYNARD. This headline is from *The Maynard News*, June 23, 1899: "A horseless carriage is expected to arrive in town soon. It has been ascertained that Dr. Frank Rich was the owner and the first to have an automobile in Maynard."

AMORY MAYNARD HOUSE. This house was built by Amory Maynard as his private residence on Main Street, opposite the mill. He lived here for 20 years before moving to his new home on the hill called "Beechmount."

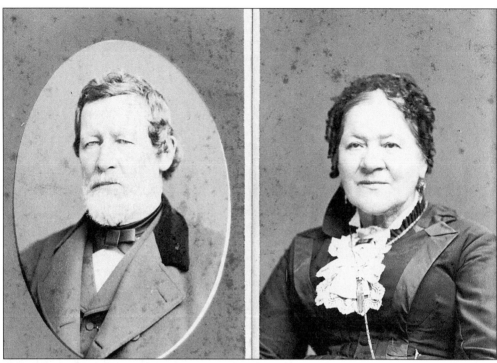

AMORY AND MARY MAYNARD. Amory Maynard was born February 28, 1804, and was the son of Isaac and Lydia (Howe) Maynard. He married Mary P. Priest on January 26, 1826. Both Amory and Mary lie buried in the Maynard family tomb at Glenwood Cemetery.

LORENZO MAYNARD HOUSE. This home of Lorenzo Maynard and his wife, Lucy, was located on Dartmouth Street. It was a grand estate with a stable and servant quarters. When Lorenzo died, it was said that he was a millionaire. This photo was taken in 1931. The house is still in use today as a multi-family residence.

AMORY MAYNARD II. Amory Maynard II was a direct descendant of Amory Maynard, after whom the town was named. He was the son of William Maynard, and his wife's name was Clara.

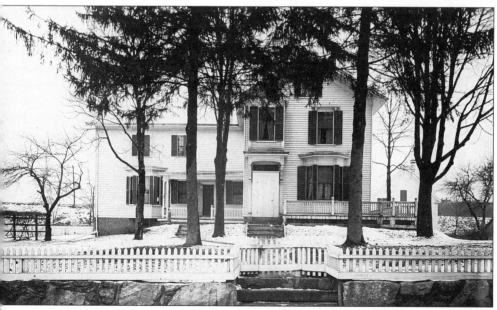

RESIDENCE OF AMORY MAYNARD II The residence of Amory Maynard II was located on the corner of Main and Nason Streets and was moved to Bancroft Street in 1935. When the house was being moved, an early winter storm occurred that resulted in the house spending all winter halfway up Walnut Street.

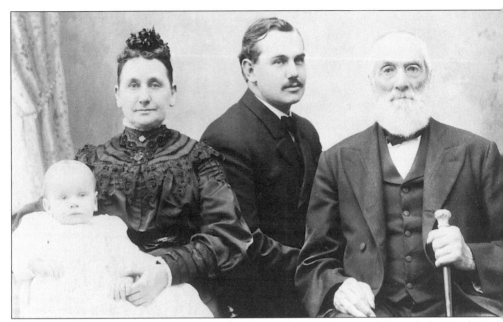

ARTEMOUS WHITNEY. Shown in this picture, from left to right, are as follows: baby Frank Case, wife Lucy, Ralph Whitney Case, and Artemous Whitney. Artemous built the Ben Smith Dam, dug the canal to the mill pond, and built over 200 foundations for early Maynard homes. (Case.)

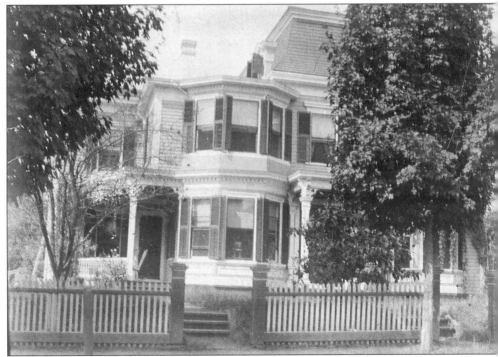

W.B. CASE HOUSE. The Case house is located on Maple Street. The owner of the house, William B. Case, operated the dry goods store that was located on Nason Street, at the present site of the Outdoor Store. The house is currently used as a four-family home at #4 Maple Street.

Thomas Hillis. Thomas Hillis was a prominent attorney who served as water commissioner and on other town boards. He was a pupil at the Brick School in district #5.

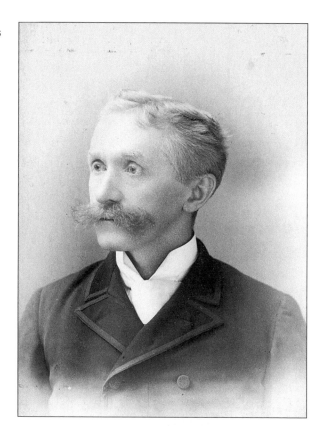

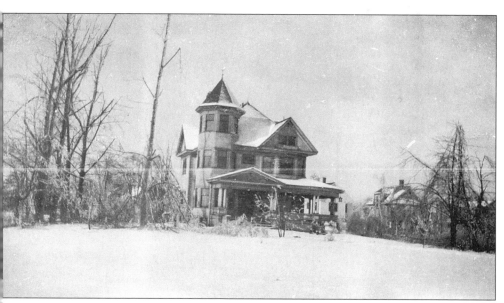

Thomas Hillis House. This house was built in 1899 by Thomas Hillis, a prominent lawyer in Maynard and Boston and an agent at the Assabet Mill. The house is located on Summer Street and was occupied by O.C. Dreschler. Today, it is owned by the Warila family.

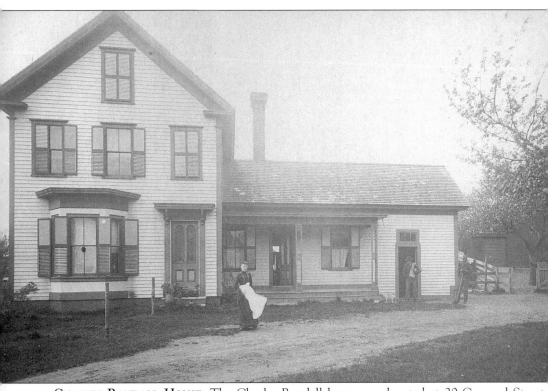

CHARLES RANDALL HOUSE. The Charles Randall house was located at 20 Concord Street. Randall owned all of the land around it, and Randall Road was named after him. Jeannie Murphy is the woman in the picture, and at that time, the house was owned by Ruby Hamlin.

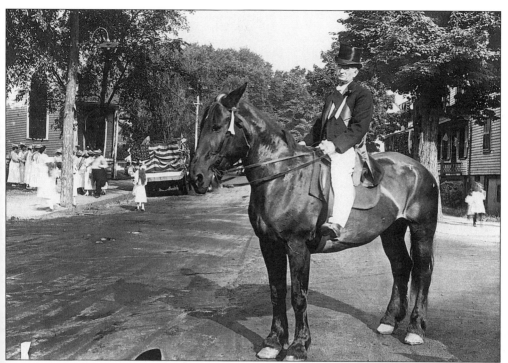

JOSHUA EDWARDS. Joshua Edwards is shown here as the parade marshal for one of Maynard's many parades. The picture was taken on Main Street by a photographer from the Methodist church.

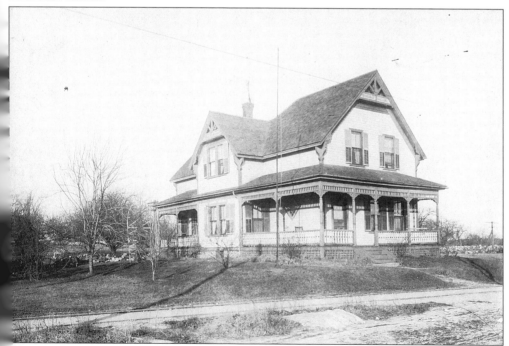

JOSHUA EDWARDS HOUSE. The Joshua Edwards home on 15 Brown Street is a good example of Victorian-style home, with its wrap-around porches and detailed trim.

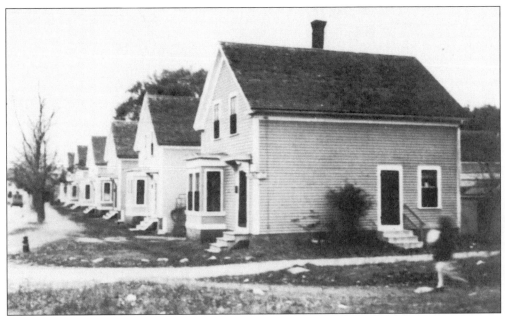

VILLAGE COLONIALS. This is a typical mill house owned by the mill and rented weekly to its employees. Typical rent in 1931 was $3.50 per week. These homes are on Sudbury Street.

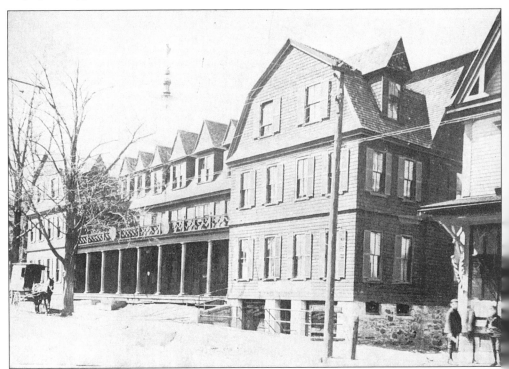

MIDDLESEX AND ASSABET HOUSE. This house was built as a rooming house with 39 rooms, 4 tubs, and 12 toilets, and each room rented for $25 a month. The building was owned by the mill, and most furniture belonged to the mill. The building was used as Maynard Town Hall until the present town hall was built. Now the building is the site of the Maynard Post Office.

Three

PEOPLE

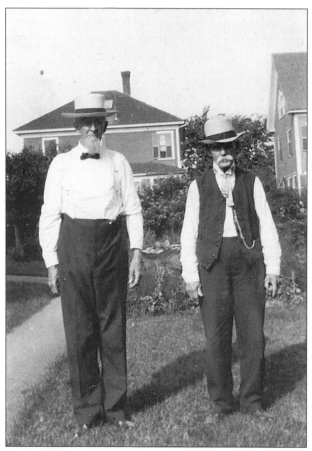

CIVIL WAR VETERANS. This picture, taken in 1915, shows Lucius Wilson (left) and James Carney, who were the last surviving veterans from The Great Rebellion. At the time of the war, 1861–1865, the name of the town was still Assabet Village.

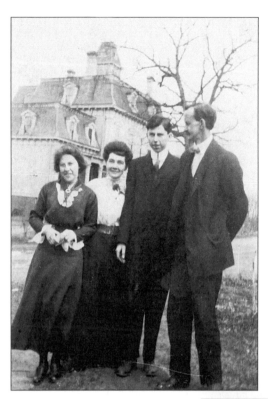

WILLIAM KENYON AND WIFE. This picture was taken in 1915 on Elmwood Street, with the Maynard Mansion in the background. From left to right are as follows: Florence Byron, Mrs. Kenyon, William Byron, and William Kenyon. Mr. Kenyon was quite poetic and wrote a considerable amount of poetry for *The Maynard News*.

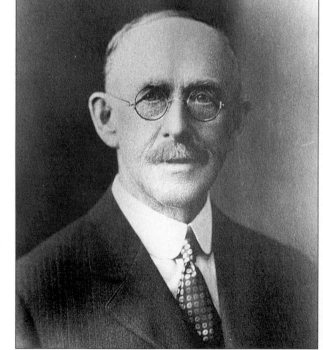

ORREN S. FOWLER. Orren Fowler served in many town offices and committees. He served for 5 years as selectman, 19 years as an assessor, 18 years on the board of health, 14 years on the board of welfare, 29 years as water commissioner, 14 years as cemetery commissioner, and 2 years on the school committee.

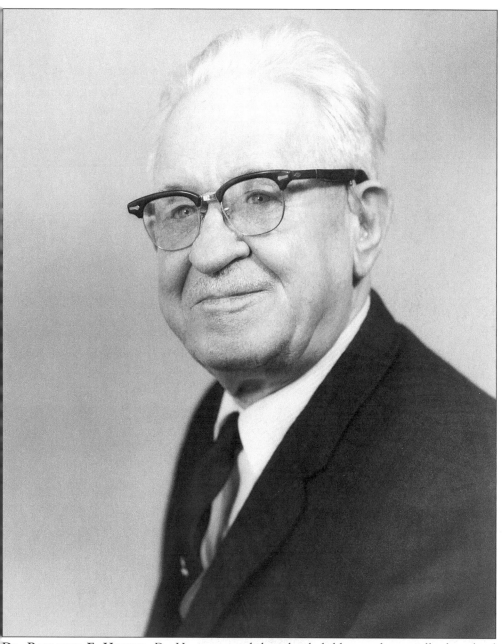

DR. RAYMOND E. HOOPER. Dr. Hooper served the school children and especially the school athletic team for 17 years. He served the Town of Maynard for 46 consecutive years. He was always on call 24 hours a day and never refused medical assistance to the underprivileged or needy.

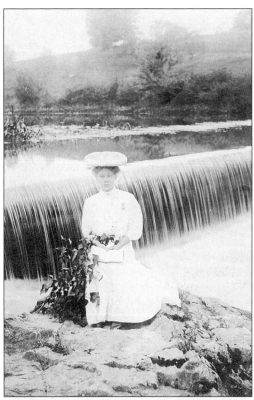

SUNDAY AFTERNOON AT THE BEN SMITH DAM. A lady from Maynard is visiting the dam on a sunny summer day in 1906. The building of the dam created a large basin in the Assabet River that became a popular recreation area.

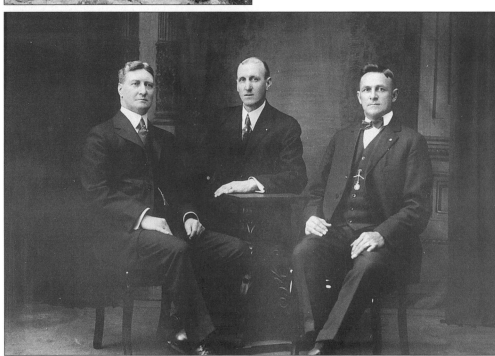

MAYNARD BOARD OF SELECTMEN, 1921. Shown in this very formal and stern pose are, from left to right, as follows: Edwin Carlton, Frank Binks, and Charles Keene.

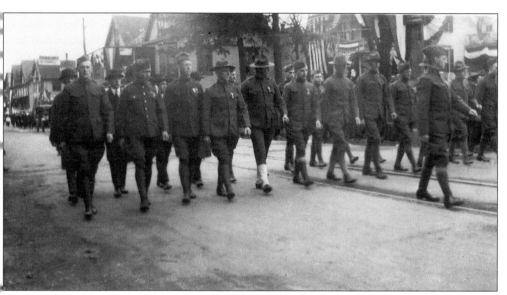

VETERANS ON PARADE. In this photo, WW I veterans march in a parade through downtown Maynard in 1921. In the war, which America entered into on April 6, 1917, Maynard furnished 340 men, seven of whom died serving their country.

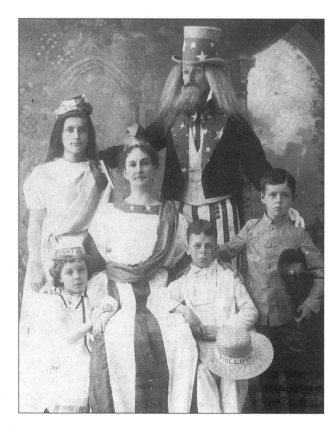

UNCLE SAM AND FRIENDS. Aquilla Ruynard of 99 Brown Street played Uncle Sam for the town and is seen here in 1900, during Maynard Merchant Week. He worked for the American Woolen Company for 40 years.

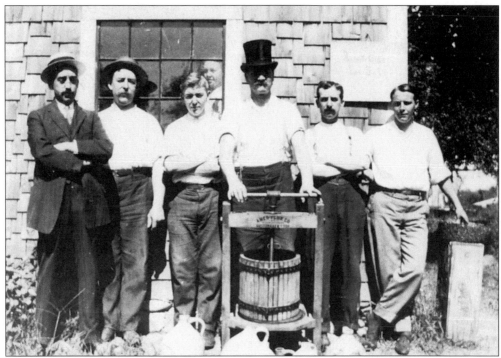

CIDER MAKING. Standing behind their cider press are the following, from left to right: Clarence Broadbent, Arthur W. Martin, Herbert Martin, Thomas Usher, William Coulter, and George Lawton. They are making cider at Lincoln Street. Cider making was prohibited during prohibition because, if left to ferment, it would make alcohol.

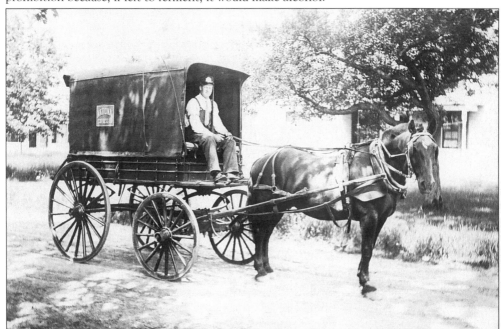

AMERICAN EXPRESS. Ralph Prescott is shown here driving the American Express wagon. In those days, most packages were delivered either by train or by express wagons.

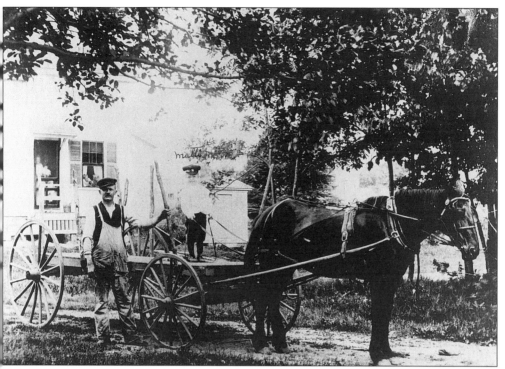

HORSE AND BUGGY DAYS. Toby Saisa and his son Matison are about to go out and attend to chores on River Street in the 1900s. The automobile would soon replace the horse and buggy as the main means of transportation.

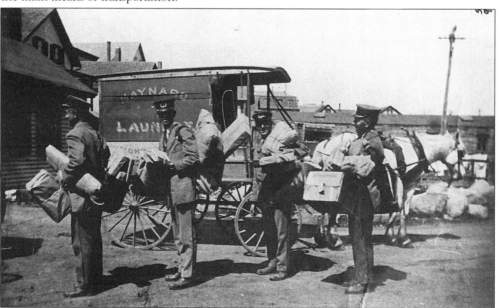

MAYNARD MAIL CARRIERS. Carrier service was instituted at the Maynard Post Office on May 1, 1920. The first four carriers appointed appear in this picture. They are, from left to right, as follows: William A. Sweeney, George E. "Speck" White, James H. Eaton, and Harold V. Sheridan.

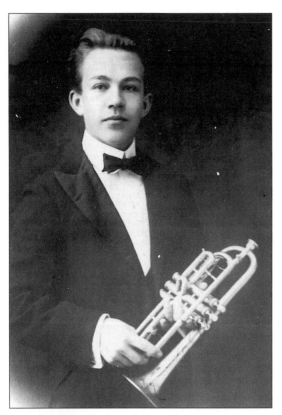

WAINO KAUPPI. This boy wonder on the cornet became the most prominent of all of Maynard's individual artists. At 12 years of age, in 1911, he was triple-tonguing at a band concert on a chair so he could be seen. He played with Teel's Band of Boston, and was listed with the White Bureau for concerts. He played with McEnelly's Dance Orchestra, did theater work in New York, including the Ziegfield Follies, and played with Goldman's Band on radio. He was considered the best cornetist in the country. He died in New York City on Thanksgiving Day, November 24, 1932.

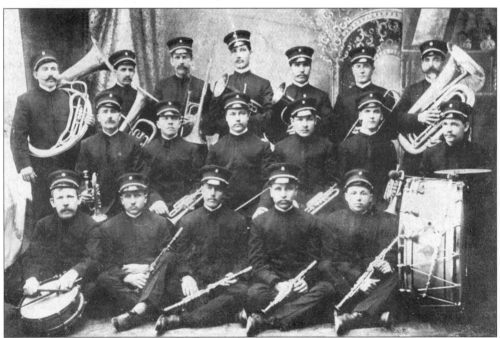

MAYNARD MILITARY BRASS BAND. The band was organized in 1884. In April 1912, the band presented their 28th free annual concert.

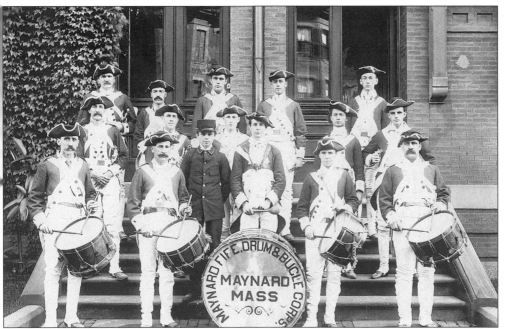

MAYNARD FIFE, DRUM, AND BUGLE CORPS. Here is the corps playing at Boston in September 1898. From left to right are as follows: (front row) Tim Crowley, Mike Goff, Albert Smith, George Smith, Charles Smith, and Fred Axford; (middle row) Charles Usher, Fred Morris, Albert Larkin, William Davis, and Jack Veitch; (back row) Thomas Usher, William Stokes, Fred Lawton, and George Lawton Sidney Coulter.

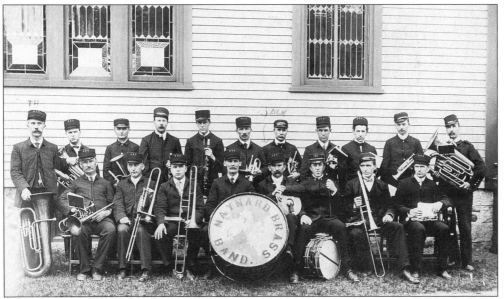

MAYNARD BRASS BAND. Shown here is the band playing in the early 1900s. Pictured from left to right are as follows: (front row) Bill Jones, Ernest Wollerscheid, Tom Wright, Si Sawyer, Jack Wollercheid, Percy Blodgett, Fritz Oschelagel, and Ted Carlton (leader); (back row) Theodore Wollerscheid, Albert Smith, Nat Cole, unidentified, unidentified, unidentified, unidentified, unidentified, Chick Lyons, Ed Sheridan, and unidentified.

41

GOOD TEMPLARS. The oldest fraternal organization in town was Iola Lodge No. 91, International Order of Good Templars. It was organized in Assabet Village on February 19, 1866, with 50 charter members. Its object was the promotion of total abstinence from the use of alcoholic beverages and of universal prohibition of the manufacture and sale of such products. The Lodge dissolved in 1907.

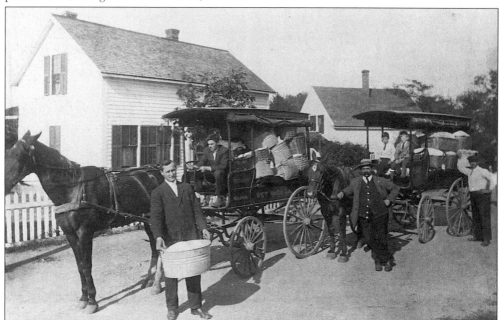

WALDRON AND PETERSON WET WASH LAUNDRY. Dennis Waldron and Hans Peterson were proprietors of the laundry. The driver of the first wagon was Vin Waldron, and in the second wagon are Charles and Al Lerer. Henry Tolman joined the firm after Dennis Waldron resigned. The company went on to be called Middlesex Launderers and Cleaners, Inc. in 1946.

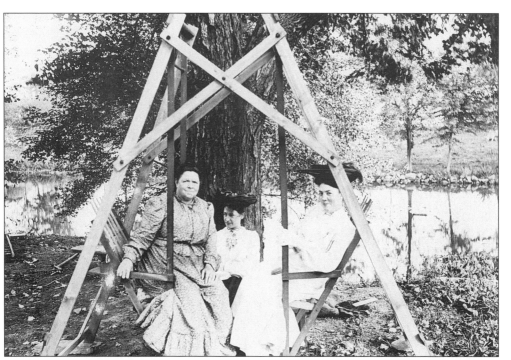

LAZY SUNDAY AFTERNOON. Grandma Bower and her family are relaxing on the swing along the banks of the Assabet River, on Acton Court.

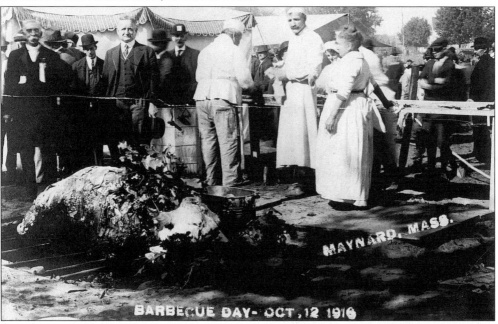

BARBEQUE DAY. Louis Agrondi and his staff are preparing an 800-pound steer on Barbecue Day, October 12, 1916. At lower left is Reverend A.M. Osgood of the Methodist Church, the Honorable John F. Fitzgerald (a long time favorite in Maynard and the grandfather of President John F. Kennedy), Joshua Edwards (a member of the committee for the affair), and Officer Harlow Greene of the Maynard Police Force.

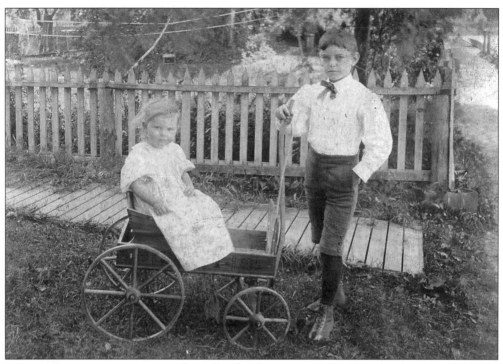

BEST OF FRIENDS. A young man dressed with a bow tie is pulling his younger sister about the yard in a model express wagon in the early 1900s.

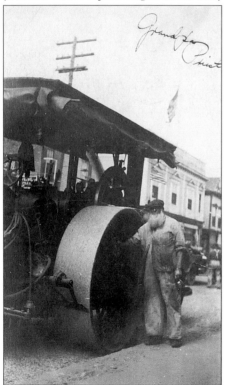

WILLIAM G. PRIEST. William G. Priest is shown here operating the town steam roller at Nason Street. He served in the U.S. Navy during the Civil War.

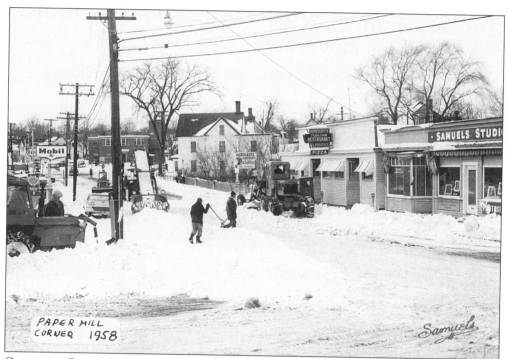

CLEARING SNOW AT PAPER MILL CORNER. Maynard public works are out with their equipment, cleaning snow in 1958. A snow loader would load snow in town trucks and then the snow would be dumped into the river.

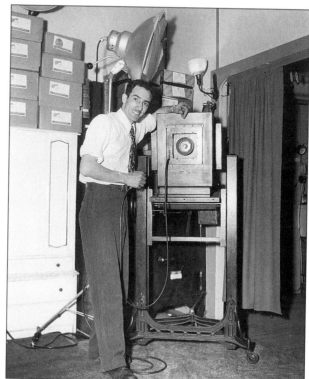

SAY CHEESE. Samuel Micclche, local photographer, is seen here standing by one of his cameras in Samuel's Photo Studio. He took many of the original photos that appear in this book. (Micclche.)

45

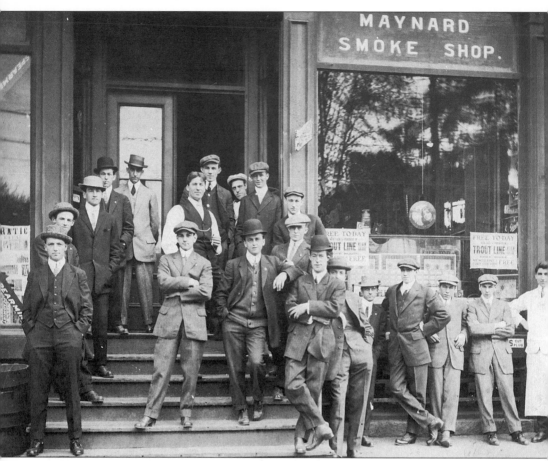

MAYNARD SMOKE SHOP. Cornelius Lynd, a former state representative, purchased the business of a Mr. Connors in 1907, and in 1910, he moved the business to the basement at the Masonic Building. Shown in the left column, from front to back, are William Mann, William Tobin, Jim Murray, Harry Higgins, and Phil Bowers. In the next column (center of stairs) are E. Mahoney, Gwen Duggan, and Carl Marsh; (next column) R. Lingley, W. Sweeney, and L. McCarthy; (next column) A. Ledgary, E. Tobin, and J. Priest. At the bottom, right, in front of the window, from left to right, are W. Stockwell, M. Lesage, D. Lowney, and T. Maley.

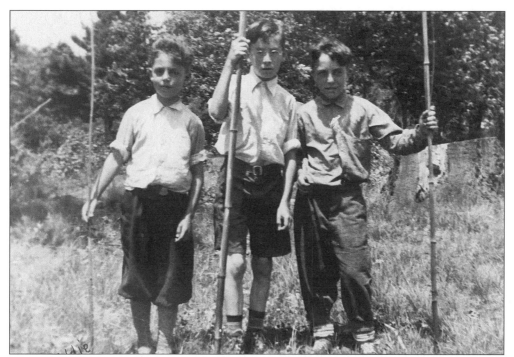

HUCKLEBERRY FINN. Eddie Lalli, Dick White, and Bob Lalli try their luck and tell the story of the one that got away. (Rod & Gun.)

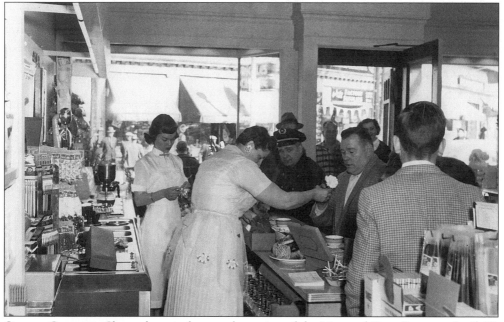

GRAND OPENING. Shown here is the grand opening of the Maynard Drug Store on April 18, 1957. Pictured, from left to right, are as follows: Audrey Malcolm, Mike Zapareski (police chief) in doorway, John Malcolm, Alba Lattuca, and Yash Sokolowski (selectman). With his back to the camera is John Malcolm Jr. Alba is giving Yash a flower, and Audrey is preparing to pin a corsage on herself. (Malcolm.)

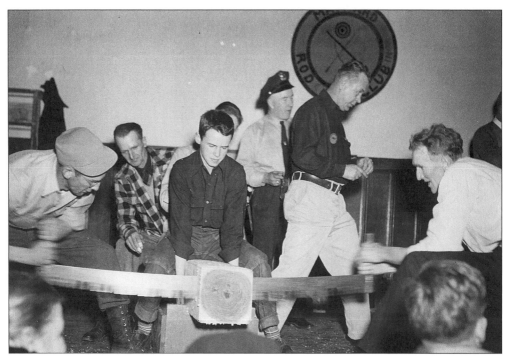

LOG-SAWING CONTEST, 1955. Shown here is a log-sawing contest at the Maynard Rod and Gun Club between Hash Whitney (left) and Jack Whitney (right). The referees are Sherm Sebastion, Danny Clark, and Ted Peterson.

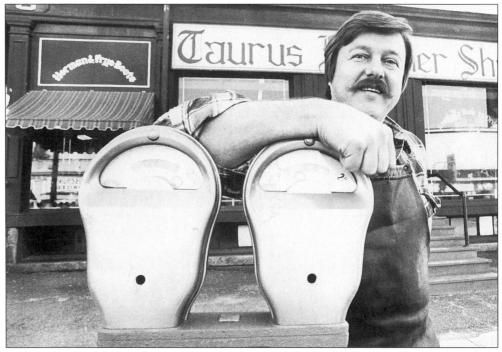

TIME IS RUNNING OUT. Barry Palmaccio, owner of the Taurus Leather Shop, is seen here spending a free moment in front of his business in the Masonic Building on Main Street.

Four
MAIN STREET

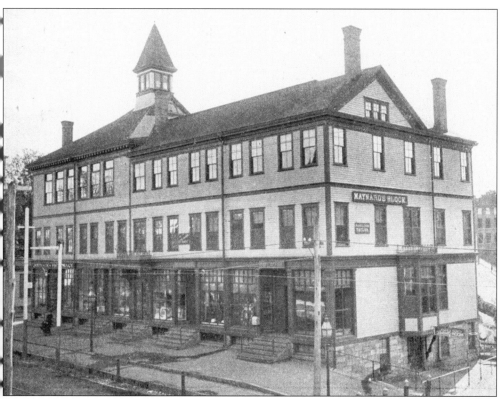

MAYNARD BLOCK. This is a view of the Maynard Block, located on the corner of Main and Walnut Streets, as it was in early 1900. It is now called the Masonic Building.

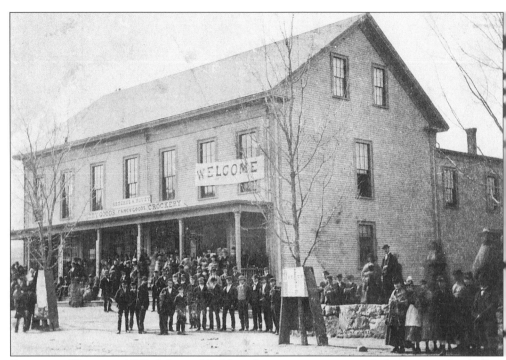

RIVERSIDE HALL IN 1872. Maynard held its first town meeting and elections at this hall in 1871. It was built in the late 1860s, and during the years from 1866 to 1868, Abel Haynes was postmaster for the post office that was located in this building. It is now known as the Gruber's Block.

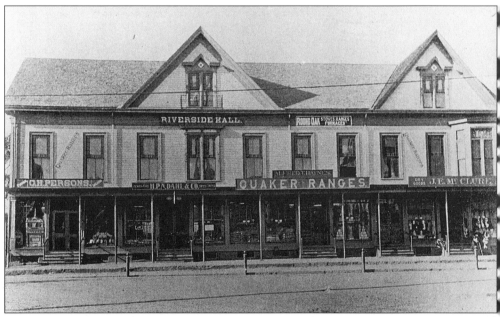

RIVERSIDE BLOCK ON MAIN STREET. This block was built in the late 1860s by the Maynard family. Its upper floor was destroyed by fire on Saturday, July 14, 1934. The Assabet Institution for Savings got its start on the second floor in 1904. It is now known as the Gruber's Block.

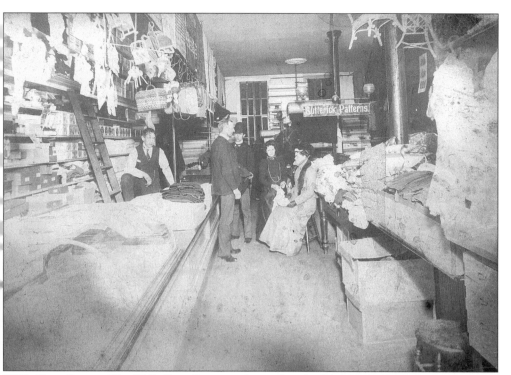

W.B. CASE STORE. The W.B. Case Store was located in the Masonic Building prior to moving to its new building on Nason Street. The Palmaccio family operated O'Bergs Shoe Store for many years in this building. Today, the Masonic Building is the site of the copy center and several other stores and restaurants. (Case.)

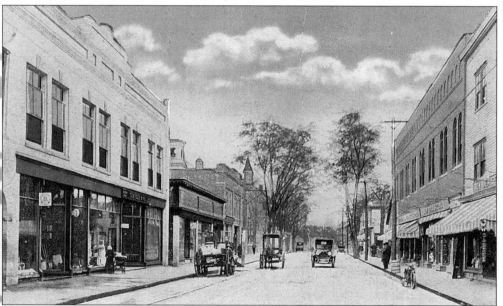

MAIN STREET, LOOKING WEST. This view was taken in the 1900s. The Cannon Block on the left was used by the Kaluva Co-op. Colonial Hall (right) was used by the Woolworth's store for many years.

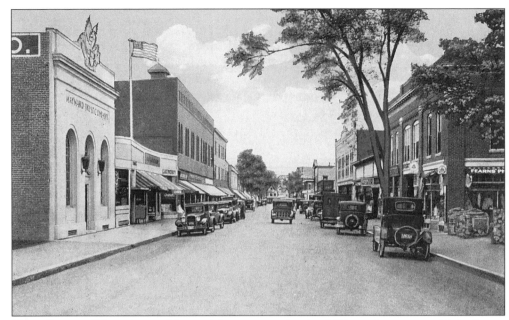

MAIN STREET. When Amory Maynard first came to Assabet Village, there was no Main Street. Rapid growth soon made it necessary to make a road through the valley, and in September 1848, Main Street was laid out, starting from Great Road.

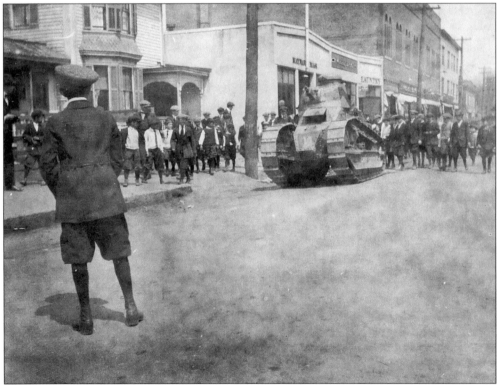

PARADE, JULY 4, 1922. This parade was held each year on Main Street to celebrate July 4th. The WW I tank was a big hit in the celebration.

AMORY BLOCK, 1921. Built by Amory Maynard in the 1880s, this building was occupied on the street floor by various types of businesses. The second floor was an apartment complex. Standing on the first floor porch are Eric Simons, William Pero, Oscar Alving, Ed Ryan, and an unidentified person. The building is now the present site of Amory's Pub.

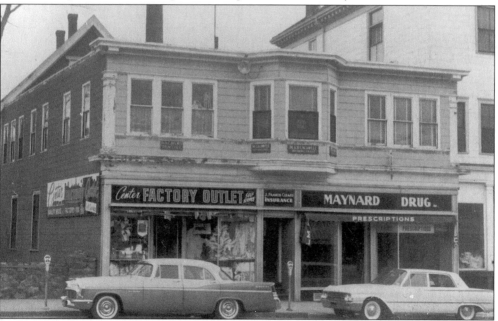

CREIGHTON'S BLOCK. This building was built in 1904. George Creighton, owner, had a shoe store in the left side, and Johnson Pharmacy occupied the right side for many years. It was located near the center of town, between the Masonic Building and the Congregational Church. For many years, the Board of Selectmen occupied rooms on the second floor. The building was completely destroyed by a fire on February 12, 1976. Fire apparatus came from as far as Framingham.

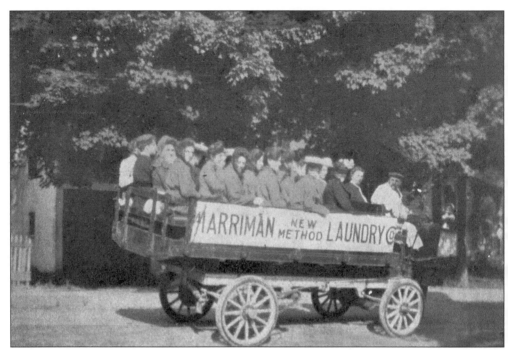

First Truck in Maynard. Harriman Brothers Laundry used their delivery truck to take their employees to an outing. At that time, the Harriman Brothers Laundry was the second largest employer in Maynard.

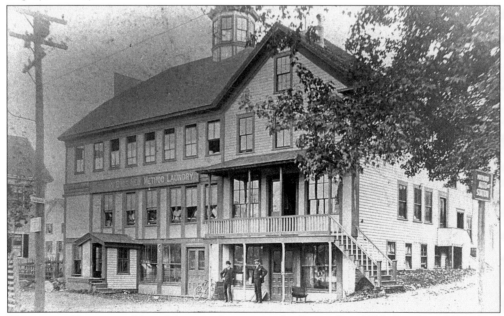

Harriman Brothers New Method Laundry. In September 1890, Frank and Rowland Harriman and a lady assistant started the Harriman Brothers New Method Laundry in two small rooms in the J.K. Harriman Building on Main Street, at the corner of Harriman Court. In 1903, it was the second-largest industry in Maynard, employing 75 people. In May 1909, the business was sold to two men from Hudson who moved the business to Hudson.

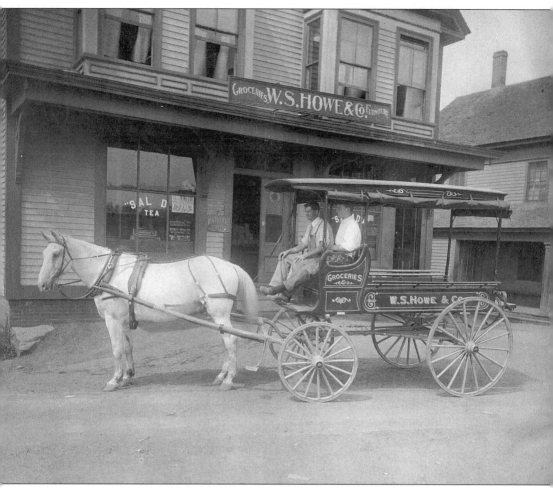

W.S. HOWE AND COMPANY. The W.S. Howe and Company grocery and variety store was located on Main Street. It was one of the first businesses in Maynard to have a telephone installed. This building is the former site of the Red Door and Grappas restaurants.

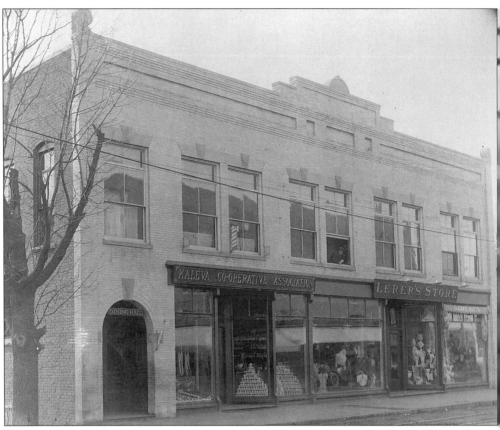

KALEVA CO-OP. The first co-op store, opened January 1907, was known as Kaleva Co-op Society. A dining room upstairs opened in 1916.

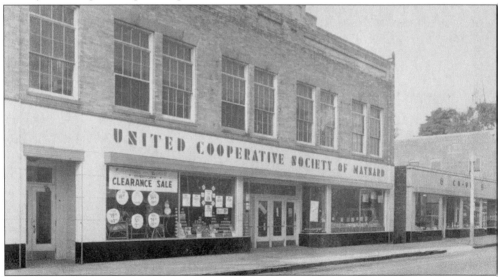

MAYNARD CO-OP MAIN BUILDING. The first floor of this building contained a supermarket, a bakery, and a dairy. The second floor contained general offices and a furniture department. The appliance store was in the building on the right.

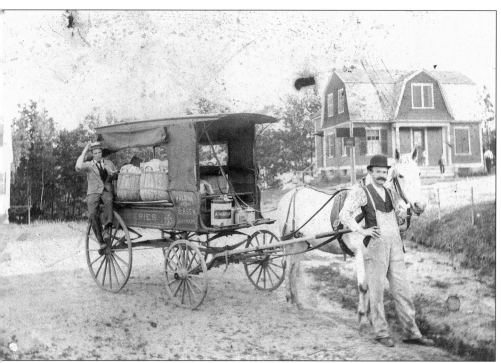

DELIVERY WAGON. This photo shows a Kaleva horse and wagon making a delivery in the new village area.

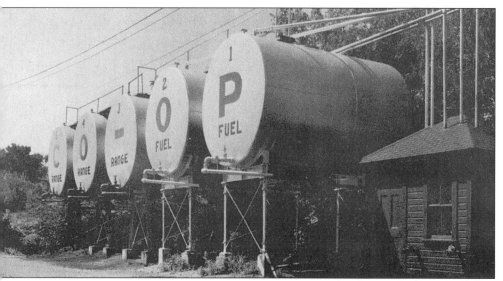

ALL IN A ROW. These Co-op oil tanks were all lined up in a row and were located on Euclid Avenue. Oil sales and delivery was one of the many services offered to the co-op's membership. The tanks are presently owned by the Dunn Oil Company.

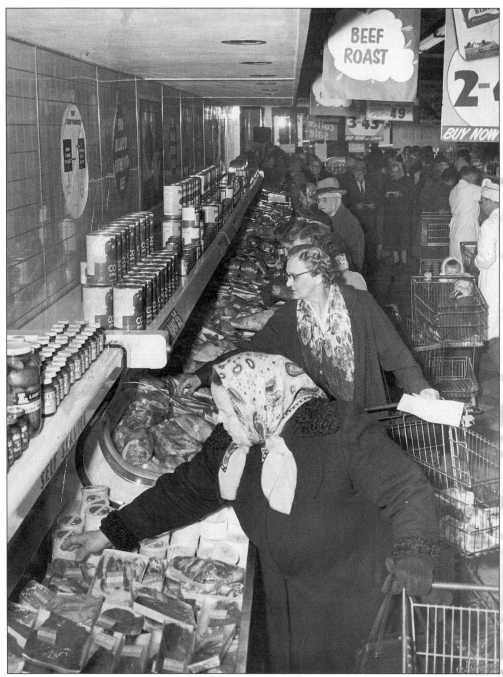

SHOPPERS AT THE CO-OP. This photo was taken about 1957. The United Co-operative Association was organized in Maynard by Finnish immigrants. In 1921, the co-op became the United Co-operative Society of Maynard, Incorporated.

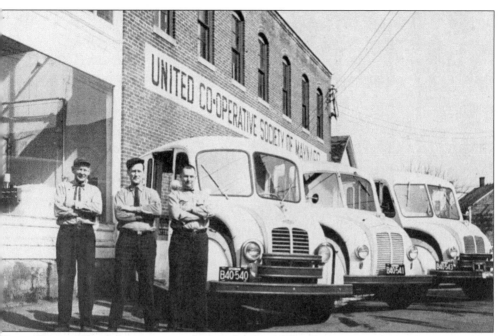

CO-OP DAIRY. These dairymen, standing at the rear of the main store on River Street are, from left to right, as follows: Ray Neimi, Waino Poikonen, and Walter Ojalehto.

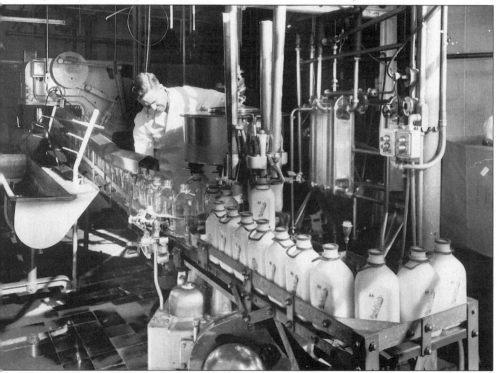

CO-OP DAIRY. In April 1950, square milk bottles were used because they were easier to fit in a refrigerator. In this photo, gallon bottles are being filled and capped at the bottling plant on River Street.

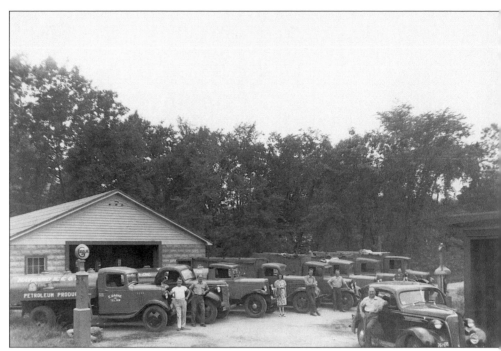

MAYNARD ICE AND OIL COMPANY. The individuals standing from left to right by the company
vehicles are as follows: Donat Gagne, Gerald Lyons, Mary (Cheney) Mayberry, Milton (Jack)
Whitney, Peter Jensen, Everete Gagne (owner), and Carl Swanson.

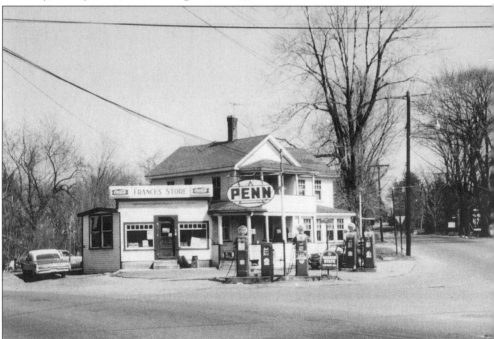

EARLY GAS STATION. With the advent of the automobile, the mom-and-pop variety store
took up the selling of gasoline. France's store was located at the intersection of Main Street and
Great Road and provided the lowest-priced gasoline in the area. (France.)

Five

NASON STREET

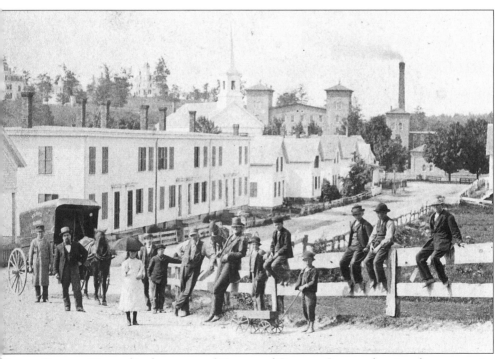

NASON STREET. Pictured is the corner of Nason and Summer Streets, showing the present site of the Knights of Columbus in 1869, when Maynard was still Assabet Village. A portion of the building on the left still exists.

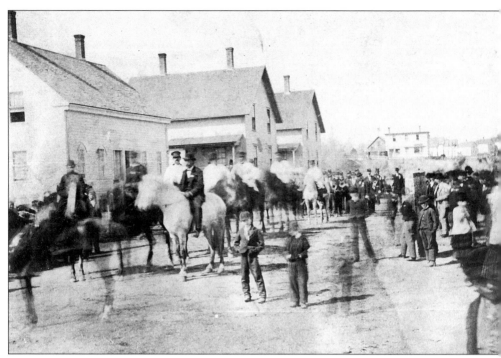

PARADE, JULY 4, 1872. Here, the parade passes Maynard's center as viewed looking north or Nason Street. Maynard was but one year old at the time of the parade. The building in the background, at the corner of Nason and Summer Streets, is still there today.

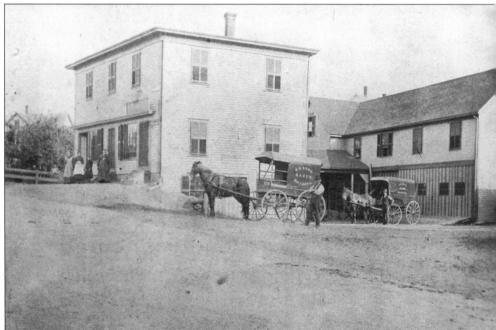

GOVE'S HOME BAKERY AND STABLE. The bakery is located on the corner of Nason and Summer Streets. They delivered daily to Maynard, Concord, Acton, Sudbury, and Stow. This building has been used over the years as a bakery, a spa, a carriage shop, and many other things

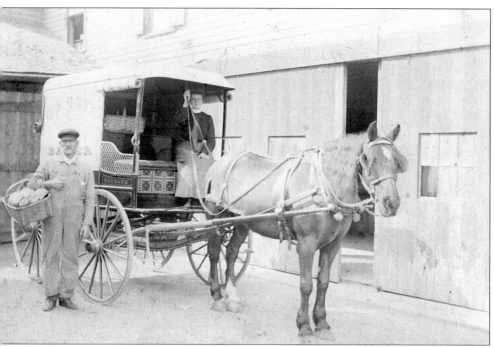

Gove's Bakery. Carrie Gove is driving the horse and wagon. The baker, who is standing by the wagon, is unidentified.

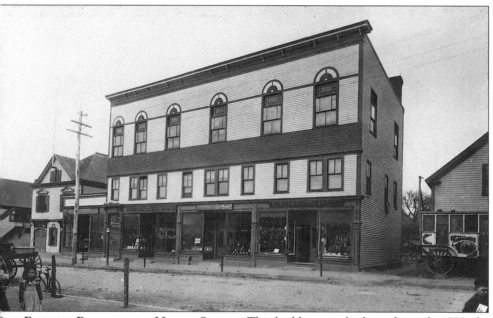

Odd Fellows Building on Nason Street. This building was built in the early 1900s for Julius Loewe, who ran a drug store in one part of the building. There was also a jeweler and a men's clothing store located in the building. On the second floor was a meeting hall where several of the local organizations held their meetings, including the lodge of Odd Fellows, which eventually bought the building. It was destroyed by fire in the late 1970s. The building is now the site of the China Ruby Restaurant.

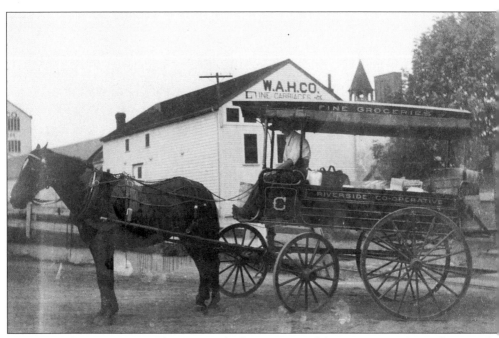

RIVERSIDE CO-OPERATIVE. This Riverside Co-operative delivery wagon, shown here at the corner of Maple and Summer Streets, is on its way to make a home delivery. The building in the back belongs to the W.A. Haynes Company.

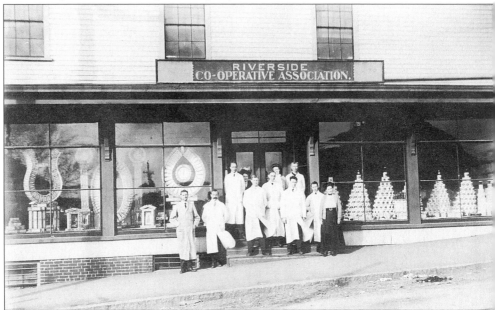

RIVERSIDE CO-OPERATIVE ASSOCIATION. This co-op was organized in 1878, and its building was erected in 1889. The association was very successful until the 1930s. The building was badly damaged by a fire in January 1936. The property was sold to the Maynard Council Knights of Columbus, who then erected the present building and dedicated it in 1937. Town meetings were held in the building for many years in a hall on the third floor. Shown in this view is the Nason Street side of the building.

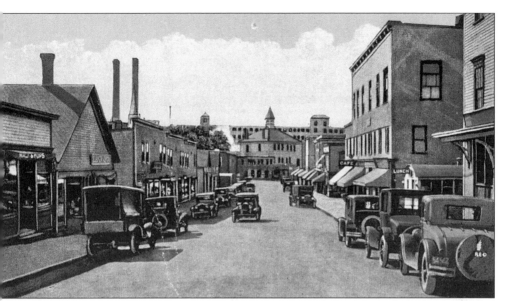

Nason Street Looking South. This picture was taken in the 1930s. Back in the mid-1850s, a lecture was given by the Reverend Elias Nason of Billerica titled "The Model Town." The lecture was highly appreciated by the townspeople. Soon after, in 1849, a road was opened between Summer and Main Streets, and a local printer, D.C. Osborn, gave it the name "Nason Street" in appreciation of Reverend Nason's lecture.

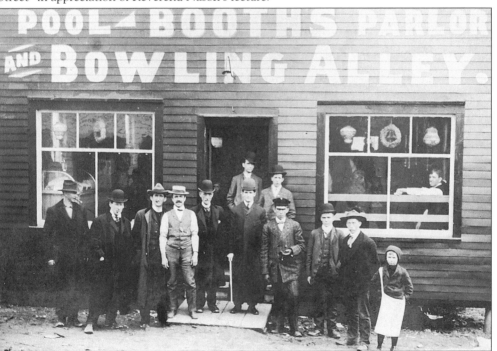

Booth's Bowling Alley. This bowling alley is located at the end of the passageway between Reed's Block and the now BankBoston bank building. Jack Booth, owner, is the one with the straw hat. The building was later owned by George "Cubie" Lynch and then "Tut" Graceffa, who moved the bowling alley to Main Street.

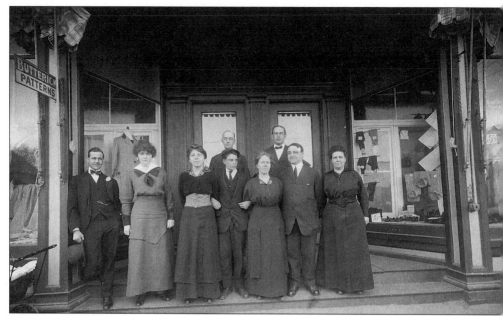

W.B. Case and Sons Dry Goods Store. This is now the Maynard Outdoor Store. Standing in the rear is Ralph Case and Howard Case. In the front row, from left to right, are Dennis Donovan, Lena Whitney, Jennie Laitila, John Carlson, Ida Jokinen, Charles Crosseley, and Mrs. Sunderland. (CASE.)

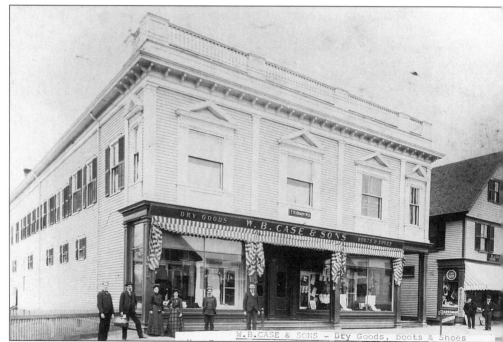

W.B. Case and Sons Boots and Shoes. Mr. Case was a longtime businessman in Maynard. This block was built in 1901 and occupied by the Cases for many years. Later, the A&P market used the building. It is now the Maynard Outdoor Store. The building next door was B.J. Coughlin's and Jim Ledgard's paper store.

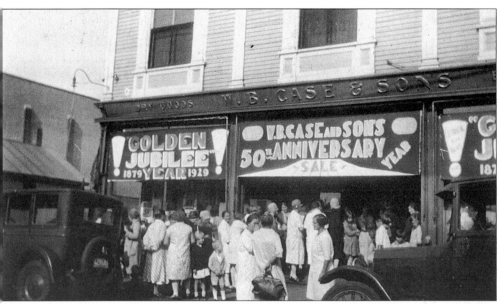

GOLDEN ANNIVERSARY. Shown here are people celebrating the golden anniversary of the W.B. Case and Sons department store on Nason Street (1879–1929). For many years, the A&P Super Market operated a grocery store at this site. Today, it is the site of the Outdoor Store. (Case.)

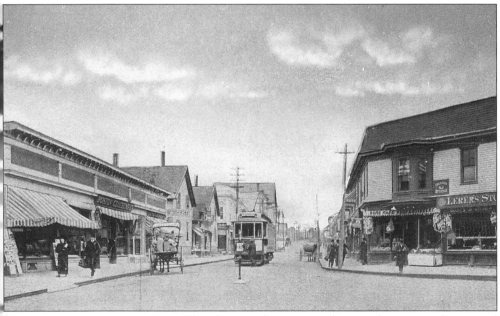

NASON STREET TROLLEY, 1914. The photographer was standing on the corner of Main and Nason Streets, looking west. A trolley is seen coming down the street from South Acton.

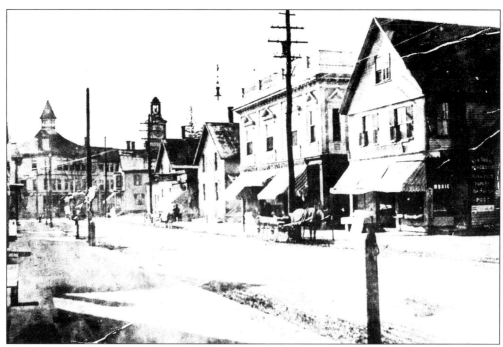

NASON STREET IN 1905. This view of Nason Street looking south shows B.J. Coughlin's paper store, W.B. Case's dry goods store, P.H. DeLee's drugstore, and Jennie Dean's millinery. Most homes on Nason Street were moved to Acton or upper Nason Street to allow new stores to be built.

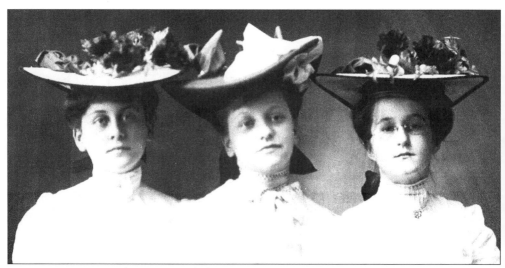

EASTER BONNETS. Three young ladies are showing off their new bonnets from Jennie Dean Millinery on May 2, 1915. On the left is Florence Salisbury, then Emma Burns and Marion Titley.

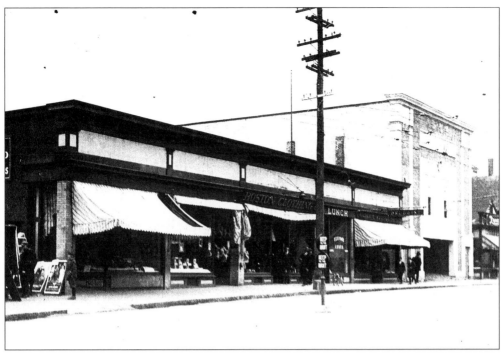

PEOPLES THEATER AND STORES. The Nason Street stores, in 1921, were Pappas Fruit, Sanderson's, Boston Clothing, Sexton's Lunch, and Macurda's Drugs. Next to the theater is DeLee's Rexall drugstore.

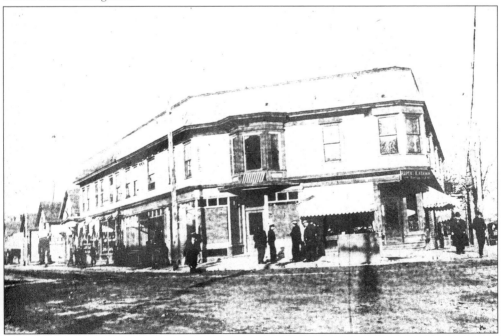

NAYLOR BLOCK. This view of the Naylor Block, located on the corner of Main and Nason Streets, was taken in the 1890s. The block was destroyed by fire in February 1917. Today, the Boston Bean House Coffee Shop occupies the site.

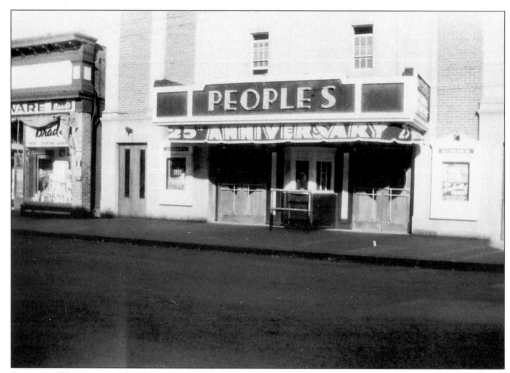

PEOPLES THEATER. This theater was built in 1921 by a group of local businessmen and was opened for business on May 6. James Ledgard was its manager. The theater was a very popular place for entertainment until the 1950s.

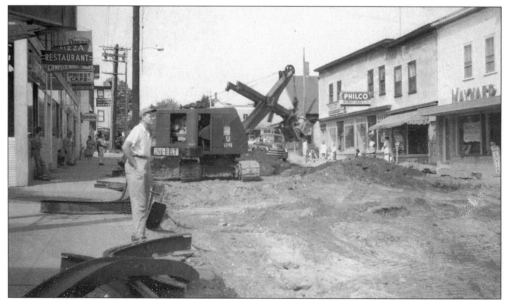

NASON STREET CONSTRUCTION. Here, Nason Street is being leveled off during the summer of 1959 in preparation for paving. Standing on the side of the street is Al Connors. At the left of the street are a pizza house and the Priest Cafe and the Diner.

Six

COMMERCE

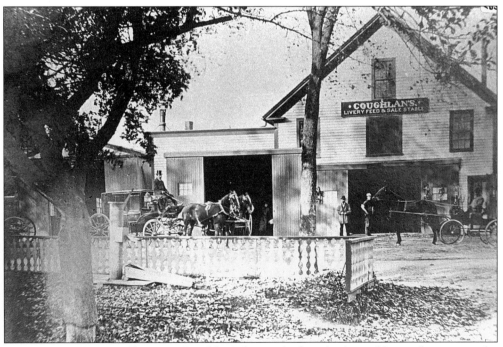

COUGHLAN'S LIVERY. Shown is Coughlan's livery, feed, and sales stable at what is now the site of the Fine Arts Theaters. At later times, the livery served as a garage for the sale and repair of automobiles.

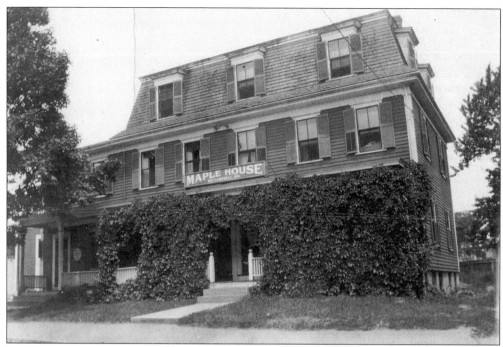

MAPLE HOUSE ON SUMMER STREET. This is where the fire and police station is located. Built in 1880 by George Cutting, it was torn down in the 1930s by St. Bridget's Parish, which had planned to build a church on the site.

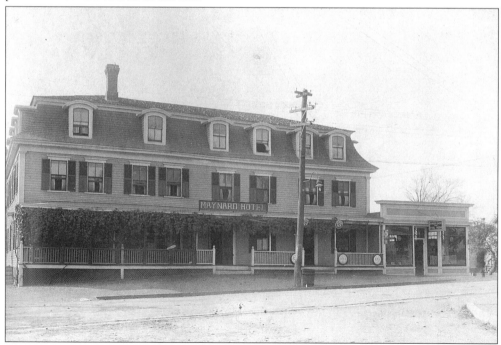

MAYNARD HOTEL. The hotel was built in 1867 on Summer Street by Peter Haley. Originally it was known as the Glendale House, and it had several owners, the last being Martin Peterson. It was destroyed by fire on January 29, 1921. A memorial park now occupies the site of the hotel.

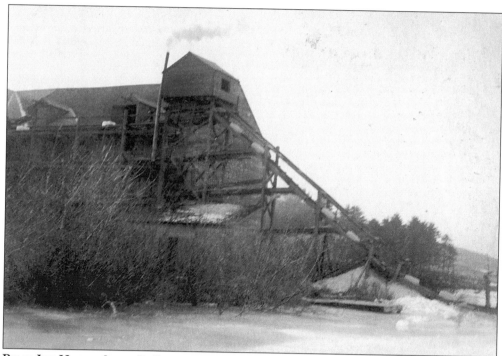

BENT ICE HOUSE. James R. Bent cut ice on Puffer Pond in 1907. From 1914, Charles "C.C." Murray operated the Bent Ice House, until it was destroyed by fire in 1918. It stood on the bank of the Assabet River.

WE WANT ICE. Fred Taylor operated the old Comeau Ice House, located on the Stow side of Russell Bridge. When you wanted ice delivered, you displayed this sign in your window.

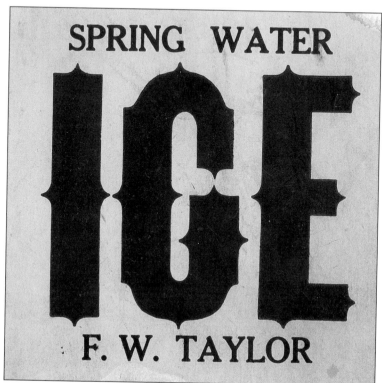

SPRING WATER

ICE

F. W. TAYLOR

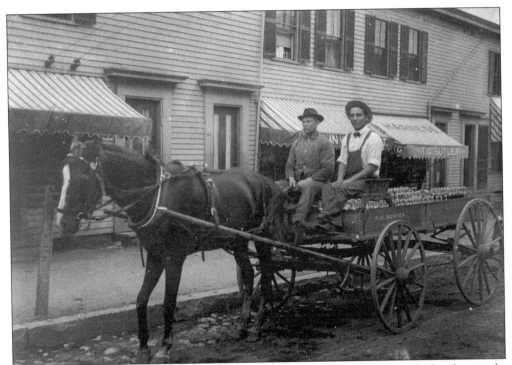

MAYNARD BOTTLING WORKS IN 1889. Shown is Waino Keto, proprietor of the bottling works that was located on the corner of Florida Road and Euclid Avenue. He sold the business to Paul Hilander in 1914.

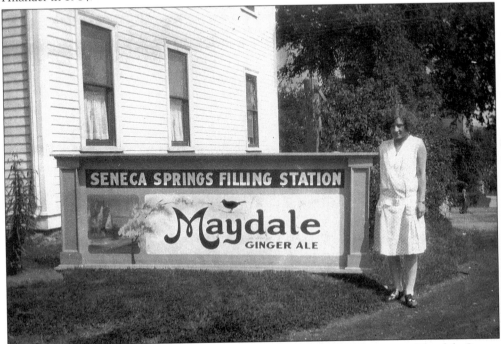

MAYDALE. This large sign was displayed in front of Paul Hilander's home on Glendale Street. From the well, he sold 5-gallon containers of fresh spring water.

MAYDALE PLANT. In this plant, bottles of Maydale tonics are being filled and capped. Flavors being bottled include Ginger Ale, Root Beer, and Birch Beer. The business was owned and operated by Paul Hilander, who had his own spring and used this water for his tonic business.

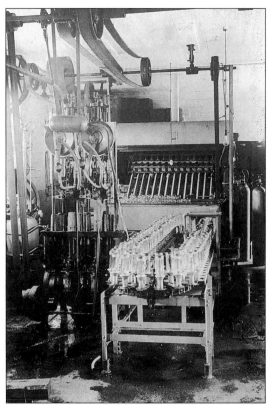

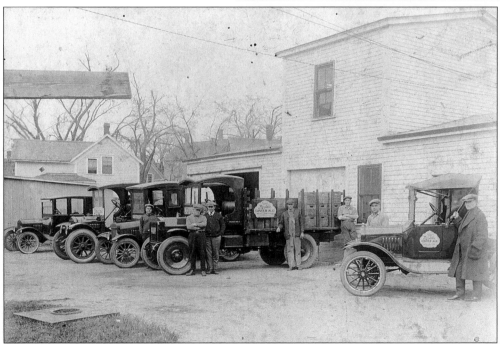

MAYDALE DELIVERY FLEET. Paul Hilander, on the right, is shown here with his fleet of vehicles for the Maydale Bottling Company.

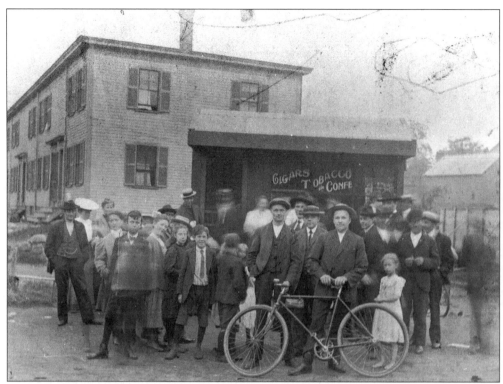

MIKE TAMLOFF'S VARIETY STORE. The store was located at the foot of Walnut and River Streets. It was enlarged later into a pool and billiard parlor. It was recently occupied by an automobile tire company.

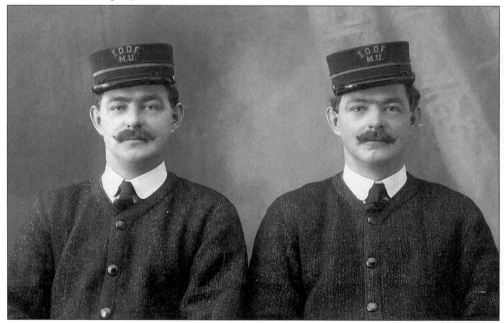

THE PRIEST TWINS. William and Walter Priest, two of Maynard's leading businessmen and identical twins, got together in their IOOF (Odd Fellows Lodge) uniforms.

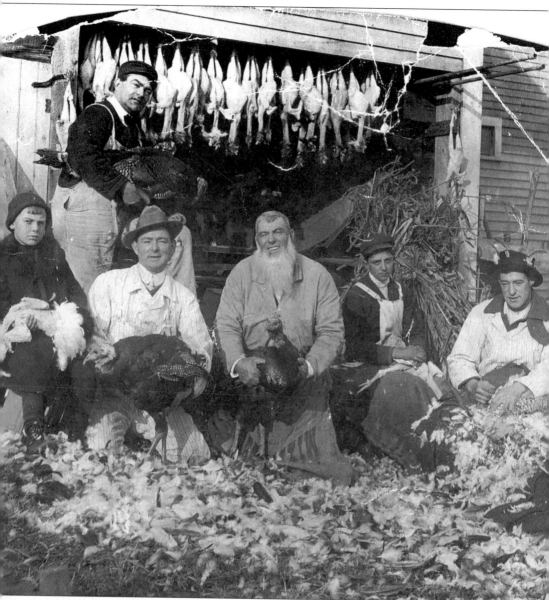

CHICKEN PLUCKING FAMILY. The Priest family ran the Central Market at the corner of Nason and Summer Streets. Standing is Lyman Priest. Seated, from left to right, are Roland Priest, Walter Priest, William Priest, "Si" Parker, and James Priest. Plucking chickens was considered, by this family, to be serious business.

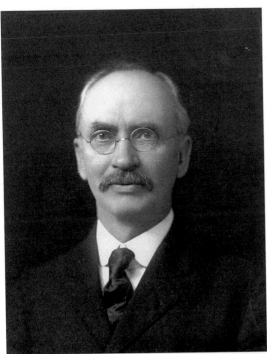

ALBERT BATLEY. In 1890, Albert Batley bought land on Acton Street to grow vegetables. In 1892, he built his first greenhouse, and after ten years, he built four more greenhouses. He shipped most of his products to Boston. Mr. Batley was also a state representative.

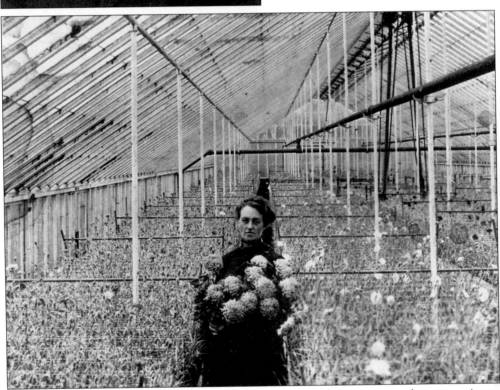

MRS. ALBERT BATLEY. Mrs. Batley is shown here in one of her many greenhouses on Acton Street. She was seriously injured in the Baker Bridge train accident in Lincoln, where she lost a leg.

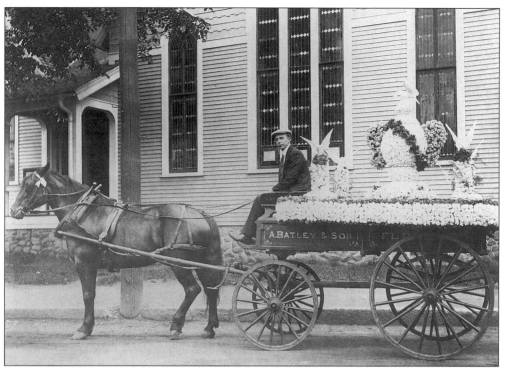

FLOWER DELIVERY. Walter Batley, son of Albert Batley, is seen here delivering flowers to the Maynard Methodist Church on Main Street.

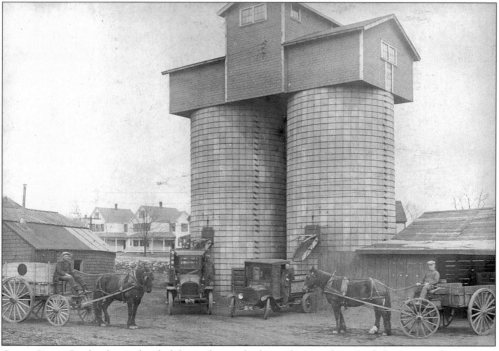

COAL SILO. Coal is being loaded from the coal silo at the Assabet Coal Company about 1926. The coal was delivered to the silo by train rail and was stored there until needed.

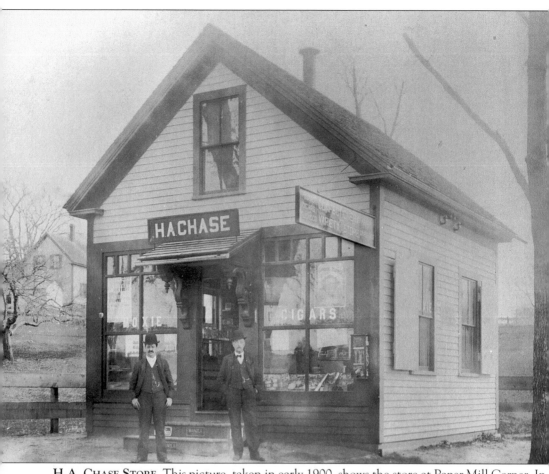

H.A. CHASE STORE. This picture, taken in early 1900, shows the store at Paper Mill Corner. In the picture are Harry Chase and Paul Wilson. The site has changed hands several times and is now occupied by Murphy and Snyder, a printing company. The original building was moved across Parker Street and is now occupied as a dwelling house.

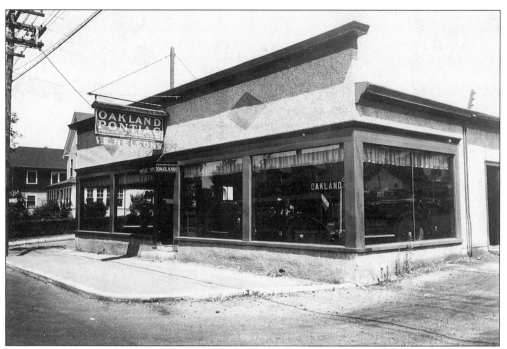

OAKLAND PONTIAC DEALER. This picture was taken in 1928 inside the service bays and shows E. Nelson at his dealership on 9 Powder Mill Road in Maynard. This building is now the site of Jiffy Lube.

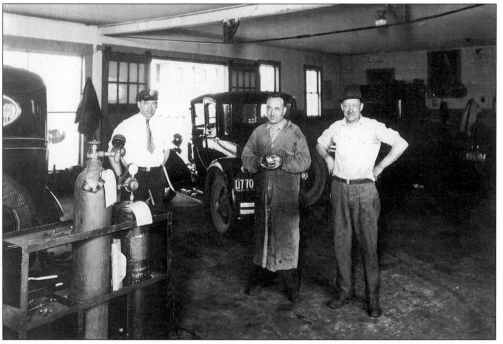

REPAIR SHOP AT OAKLAND PONTIAC, 1928. On the left of this photo is William Mahan, a bus driver for the Lovell Bus Line, in the center is Fred Strong of Stow, and on the right is Jack Waara.

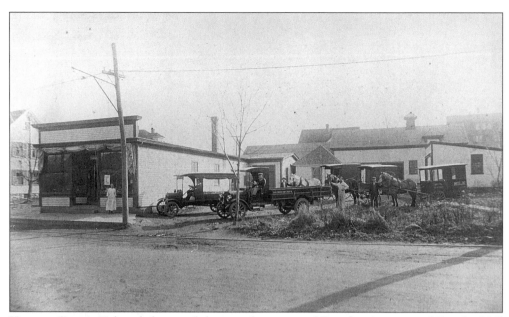

KALEVA CO-OP. Kaleva bakery and dairy at the corner of Douglas Avenue and Powder Mill Road is shown here in a 1914 photo. Today, Jiffy Lube uses this site.

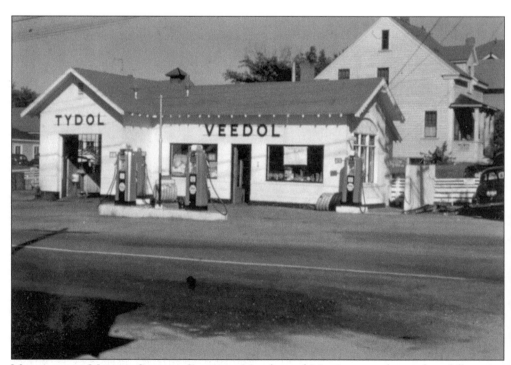

MURPHY AND MARTIN SERVICE STATION. Murphy and Martin opened a modern full service station early in 1940 on the corner of Powder Mill Road (also known as Papermill Corner). In later years, it was operated by Robert P. Whitehouse. (MURPHY.)

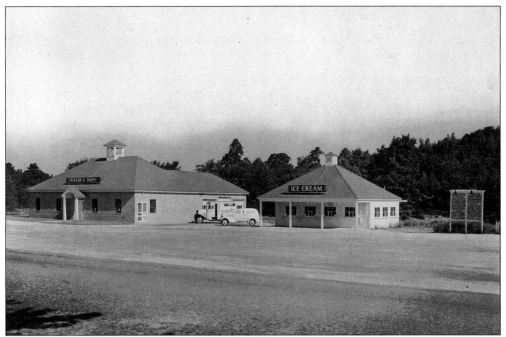

ERIKSONS ICE CREAM. Eriksons dairy and ice cream stand on Great Road is noted far and wide for its fine ice cream and has been at that location for 62 years. Hans Erikson, of Danish decent, was the founder and one of the stalwarts of the Danish Brotherhood Society instituted December 23, 1904. The society built a hall in 1912 on Hasting Street in Stow. (FRASER.)

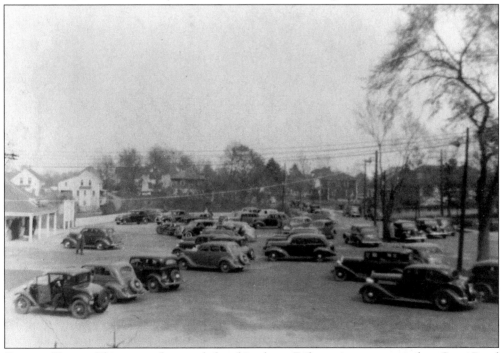

SUNDAY TREAT. This scene of a crowded parking lot at Eriksons ice cream stand on Great Road has been duplicated every April through October for over 62 years. (FRASER.)

"*Uncle Pete Carbone's*"

TWIN TREE CAFE, Inc.

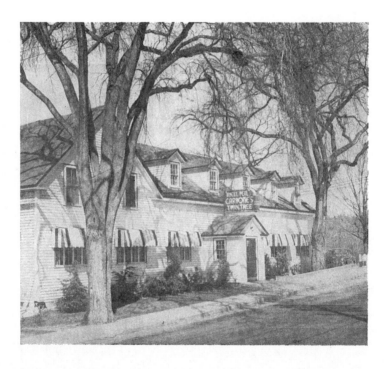

TWINOAKS 7-9851 Maynard, Massachusetts

UNCLE PETE'S MENU. This restaurant was famous worldwide for their large portions of food. Some of the restaurant's original buildings were made up of old powder mill buildings that were moved and assembled together. Today, the building is the home of the Maynard Elks.

Seven

TRANSPORTATION

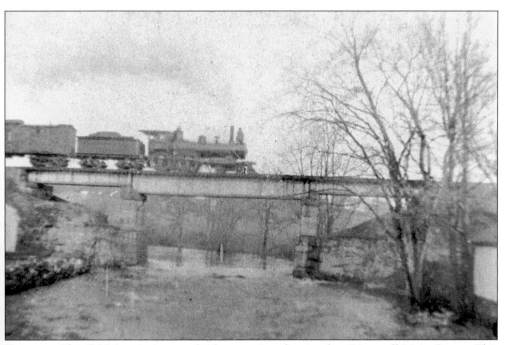

TRESTLE. This B&M train is on a bridge crossing the Assabet River off Main Street. This picture was taken in the 1890s.

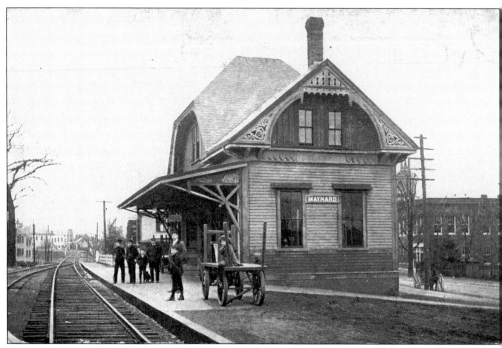

BOSTON AND MAINE RAILROAD STATION AT MAYNARD. This iron fence is around the mill yard across the street. The picture was taken in 1902 by R.J. Keep of East Jaffrey, New Hampshire, who was a railroad man. The station was demolished in 1960.

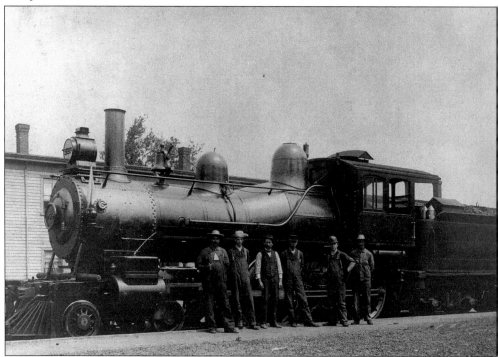

BOSTON AND MAINE ENGINE AND CREW. This photo, taken near the Maynard station in the early 1900s, shows George Salisbury, station agent, third from the left.

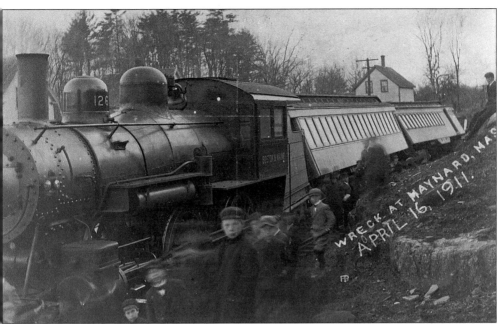

THE 1911 WRECK AT MAYNARD. On Sunday morning, April 16, 1911, a train bound from Marlboro derailed on High Street with many casualties. At one time, over 40 trains passed through Maynard daily.

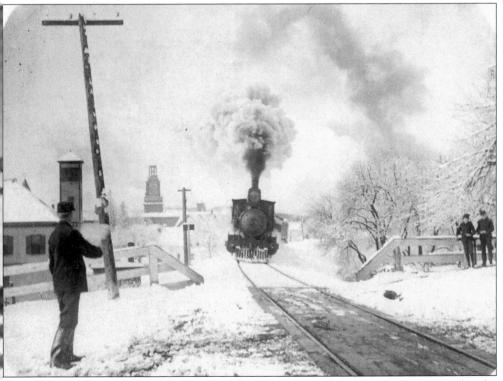

APPROACHING TRAIN. This train is approaching the Summer Street crossing in Maynard in the early 1900s and is going in the direction of South Acton.

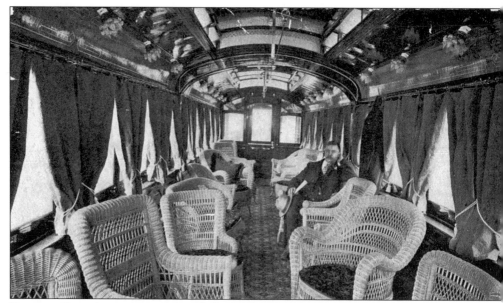

PARLOR CAR. An interior view of the parlor streetcar *Concord* shows the wicker chairs with which it was furnished. Seated in the car is John W. Ogden, superintendent of the railway in 1902.

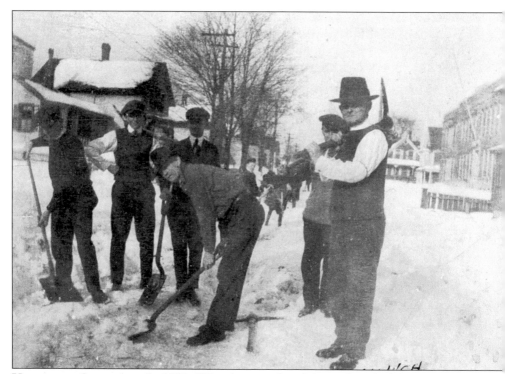

VOLUNTEER SHOVELERS. In 1920, 500 volunteers from Maynard worked for two days clearing solid ice from the tracks for the Concord, Maynard, & Hudson Street Railway Company to open up service between Maynard and Acton. Every resident in town was inconvenienced by the lack of transportation, and they did not wish to wait for a thaw.

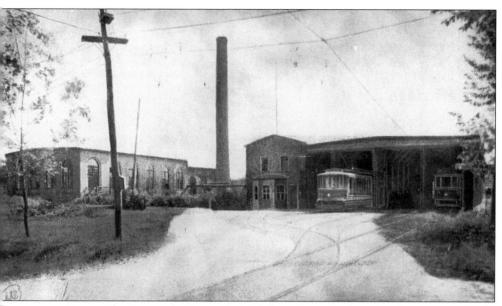

STREETCAR BARN. The Concord, Maynard, & Hudson Street Railway headquarters on Great Road is shown here as it existed in 1901. The first car to Concord ran on August 1, 1901, and the first car to Wood Square in Hudson ran on October 1, 1901. The trolley line connected at Concord Center with the Lexington and Boston Street Railway, and at Hudson with the Boston & Worcester Street Railway and with the Worcester Consolidated Street Railway. In 1903, the line extended from Maynard to South Acton, and in 1909, it extended as far as West Acton. The line prospered until automobiles took over. The last car out of Maynard was on January 16, 1923. The power station was sold to the Polish Catholics and is today the St. Casimir's Church.

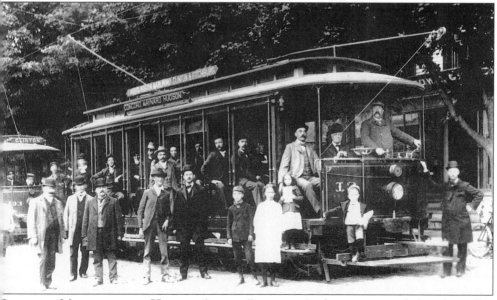

CONCORD, MAYNARD, AND HUDSON STREET RAILWAY. In this scene, people board a trolley in Maynard in 1905 on Main Street. This was one of the regular stops along the line.

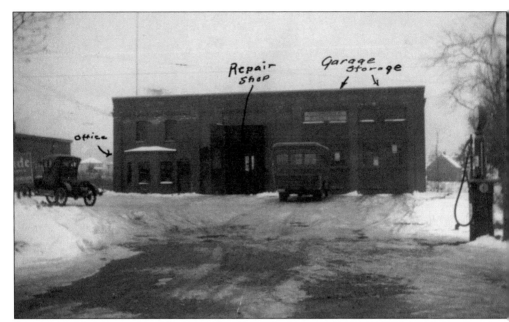

CONCORD, MAYNARD, AND HUDSON BUS LINE. In January 1923, the Woburn & Reading Bus Line started running buses between Maynard and Acton and, a month later, to Concord and Hudson. It was from these towns that it took its name. On February 18, 1924, the name was changed to the Lovell Bus Line, Inc. so that they could service other towns.

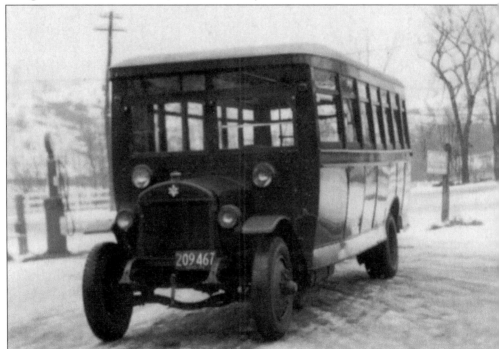

THE OLD JITNEY BUS. This is typical rolling stock for the Concord, Maynard, & Hudson Bus Line. Its name was later changed to the Lovell Bus Line. The early buses were also called a Jitney.

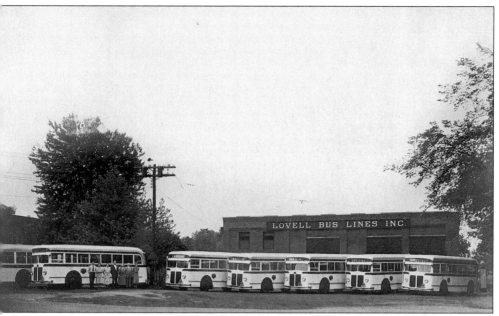

LOVELL BUS LINES. John Lovell of Woburn Bus Lines came into Maynard on January 19, 1923, with a bus running to South Acton. After permanent franchises were obtained, he began operating from Concord to Hudson. Eventually, the line was extended from Arlington Heights to Clinton and Leominster. By 1954, the line was out of business.

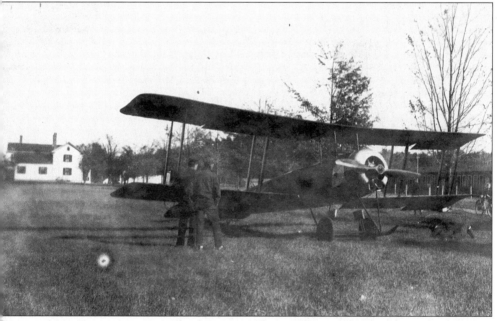

POWDER MILL ROAD AIRPORT. This bi-wing airplane is shown about 1920 on a landing strip located on Powder Mill Road, the present site of the supermarket. Rides were offered for a fee when there were no crops in the field. The house in the background is 106 Powder Mill Road. (Case.)

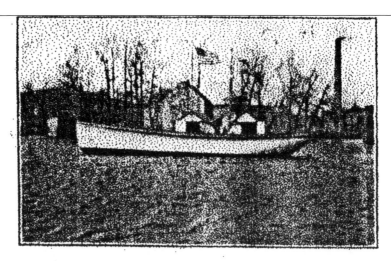

Assabet River Launches
TIME TABLE
1911

Leave Maynard		Leave Lake Boone
8.40		9.10
9.40		10.10
10.40		11.10
11.40	Subject to change without notice.	12.10
12.40		1.10
1.10	Parties accomodated by appointment.	1.40
1.40	Post Office address Box 963 Maynard.	2.10
2.10		2.40
2.40	We do not hold ourselves responsible for	3.10
3.10		3.40
3.40	delays.	4.10
4.10		5.00
5.00		5.30
5.30		6.00
6.30		6.30
7.00		7.00
7.30		8.00

SATURDAYS

Leave Maynard	Leave Lake Boone
1.40	2.20
4.40	5.20

CHANDLER, HOWARD & CO

A. M. WHITNEY, PRINTER, MAYNARD

ASSABET RIVER LAUNCH. In 1906, a license was granted to two Maynard men to operate a launch on the Assabet River for the purpose of taking parties to and from Lake Boon from Maynard. A boathouse and landing wharf were built at the river near Ben Smith Dam, and a landing wharf was built at Whitman's Crossing near Lake Boon. The cost was 25¢ one way. It ran until 1914, when the business dissolved.

Eight

EDUCATION AND

RELIGION

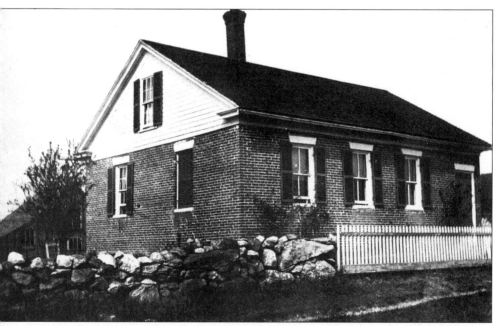

OLD BRICK SCHOOLHOUSE. This old, brick schoolhouse is on Summer Street. The picture was taken in 1921. On March 3, 1766, the town of Stow voted to build three schoolhouses in the outlying districts. There is no doubt that this was one of the three. This was the "Northeast Corner District," afterwards called "District No. 5." It was closed in 1872. Many of Maynard's honored citizens received all of their schooling within its walls. Among the pupils were George and Charles Maynard, Lorenzo and William Maynard, Browns, Abbotts, Reeds, Whitneys, Hillis's, Fowlers, Bents, Parmenters, Gutteridges, and many others. Now, the former school is used as a dwelling at 101 Summer Street.

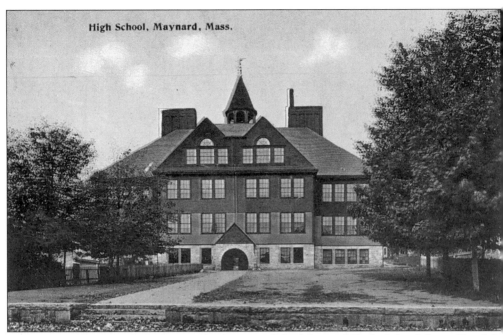

MAYNARD HIGH SCHOOL. This is a back view of the Maynard High School from Glendale Street. It was built in 1892 for $20,927 and was destroyed by fire on September 20, 1916.

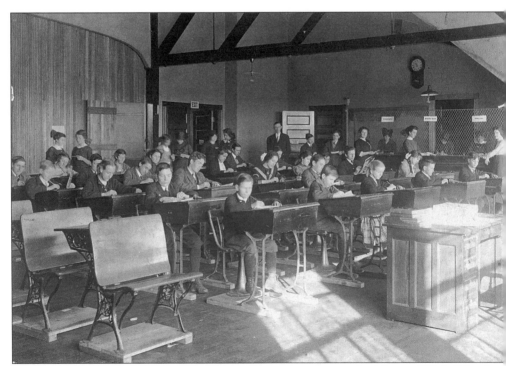

MAYNARD HIGH SCHOOL CLASS. Here is one of the classrooms at the Maynard High School on Nason Street.

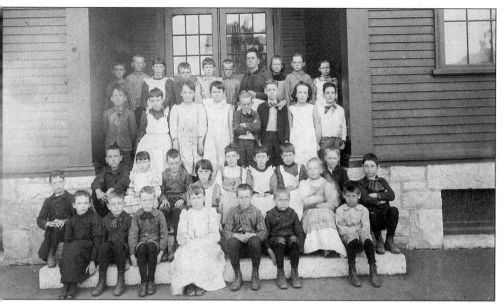

MAIN STREET SCHOOL. This photo shows students in front of the Main Street School, which was built in 1857 and closed in 1892. Now the school is the site of the Maynard Town Hall. James Mullin purchased the building for $126 and moved it to the rear of his home on Main Street.

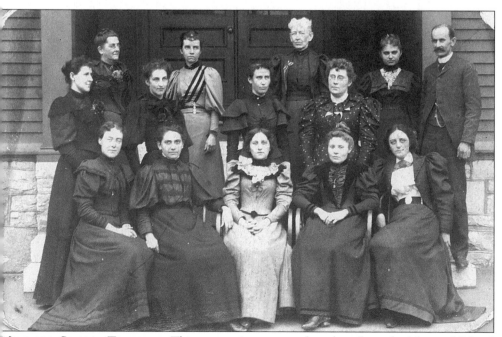

MAYNARD SCHOOL TEACHERS. This very serious group of teachers from the Maynard School got together for a photo that was taken about 1890.

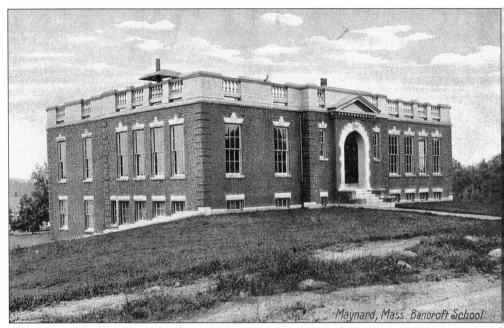

Maynard, Mass. Bancroft School.

BANCROFT SCHOOL. This school was built in 1906 on Bancroft Street. In 1909, it was voted that another story be added at a cost of $12,000.

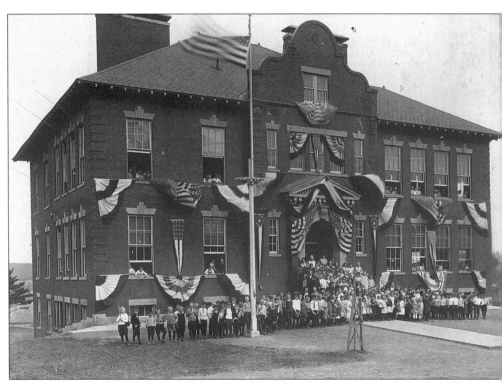

DECORATED SCHOOL. The Bancroft Street School was decorated on May 10, 1921, for Maynard's 50th anniversary as a town.

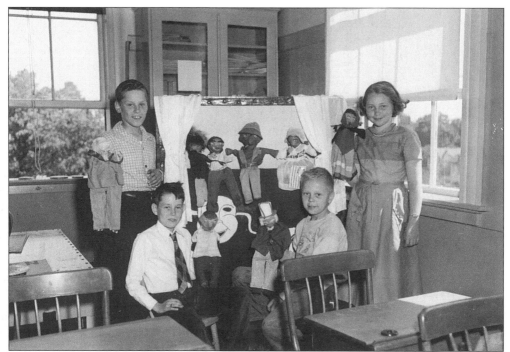

PUPPET SHOW. The kids in the fifth grade of the Bancroft Street School in 1949 were preparing to present a puppet show. Shown, from left to right, are John Soroka, Paul Boothroyd, Ray Laskowsky, and Sandra Spratt.

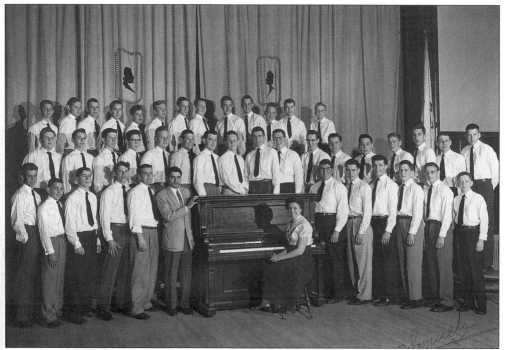

GLEE CLUB. Maynard High School Glee Club is seen here singing in the George Washington auditorium in 1955. Charles Garabedian was the conductor, and Sally Boeske was the pianist.

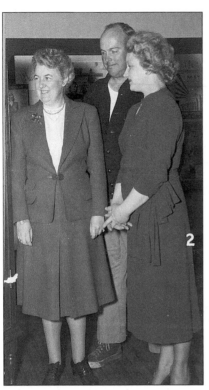

SOME OF THE 1947 FACULTY. Eleanor Colburn (music), Dick Lawson (physical education), and Ann Pasakarnis (art) get together to discuss matters of great importance.

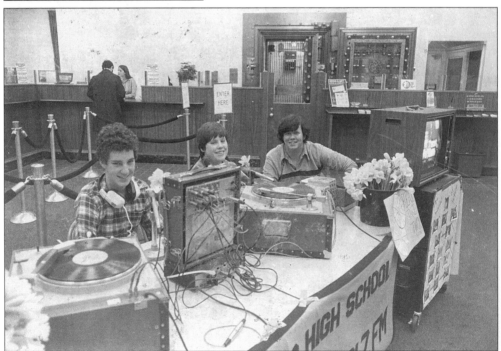

WAVM RADIO. This radio station is known as the Maynard High School's voice of TigerTown. Their station was set up within the Assabet Bank and was manned by Dave Lemire, Mike Sale, and Chris Whalen.

SALUTE TO REAR ADMIRAL WILLIAM T. SAMPSON. A Maynard salute to Rear Admiral William T. Sampson, the "Hero of Santiago," was given May 16, 1900, by primary school student "marines." The boys are, from left to right, as follows: Harold Dubur, Henry Washburn, Edward Ledgard, Archie Livingston, Roy Denniston, and Henry Fowler. Similarly, the girls are as follows: Florence Salisbury, Eva Edwards, Margaret Wagner, Edna Denniston, Alice McCormack, and Florence Hart.

JUNIOR POLICE. The boys were all dressed up in police uniforms on the occasion of the visit to Maynard by Admiral William T. Sampson on May 16, 1900. From left to right are as follows: Harrison Persons, Douglas Salisbury, Daniel Sullivan, James Ryan, Charles Dyson, and Raymond Veitch.

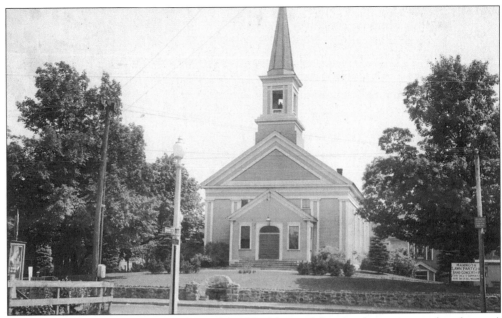

CONGREGATIONAL CHURCH. In the early 1850s, Maynard (or Assabet as it was then known) provided little accommodation to those who desired to comply with the law "Thou shall keep holy the Sabbath Day." Services at that time were held on the site that was to become the B&M freight depot on Main Street, opposite the present Maynard Town Hall. The church was built during the winter of 1852 and dedicated on March 24, 1853.

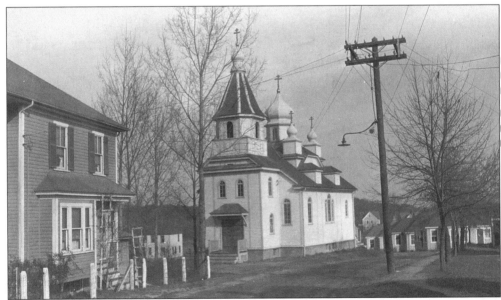

RUSSIAN ORTHODOX CHURCH. The parish of the Holy Annunciation Russian Orthodox Greek Catholic Church in Maynard was first assembled in 1915. Then in 1916, the cornerstone for St. Mary's Russian Church of Prospect Street was laid.

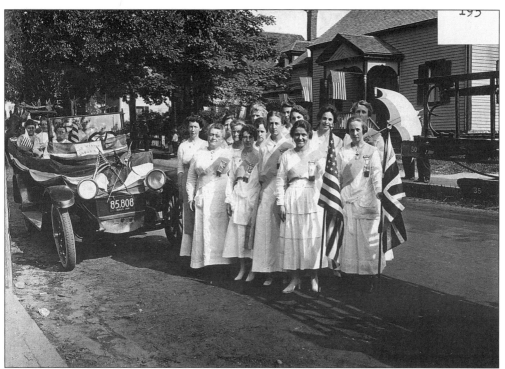

DAUGHTERS OF ST. GEORGE'S CHURCH. The membership of this church's women's group is shown posing on Summer Street in 1919.

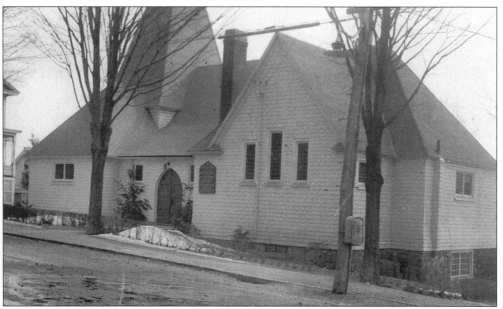

ST. GEORGE'S CHURCH. The cornerstone for St. George's Episcopal Church on Summer Street was laid August 10, 1895, and the church was consecrated on April 14, 1897.

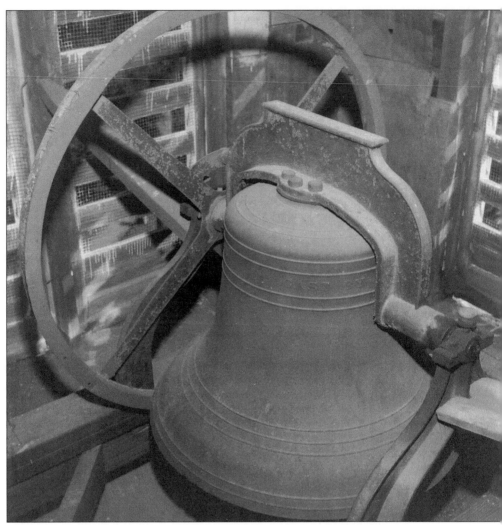

HISTORIC WELCOMING CHURCH BELL. In October 1935, Matti Katvala, then a watchman for the American Woolen Company and a member of the Finnish Congregational Church, heard that the "Curfew Bell" of the mill was to be given away. He asked Mr. Templeton, the mill superintendent, if the American Woolen Company would give this famous and historic bell to his church. Permission was granted. This "Curfew Bell," as it was known, signaled to the mill employees each night that it was 9 p.m. and that they were to be at home and in bed. Amory Maynard, their employer, cautioned them that if they were found on the streets after the bell tolled, the employees would lose their job in his company for failing to abide by its rules. This bronze bell, cast in England in 1856, now is in the belfry of the Finnish Congregational Church.

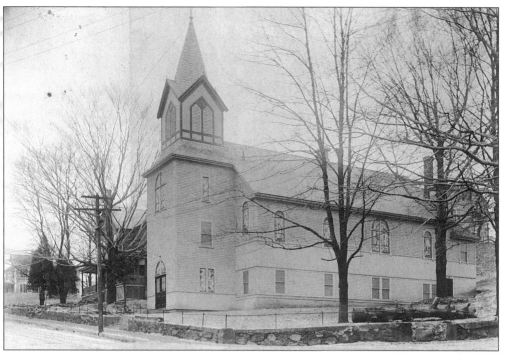

FINNISH CONGREGATIONAL CHURCH. The cornerstone for this church was laid at the corner of Walnut and Thompson Streets on May 23, 1923.

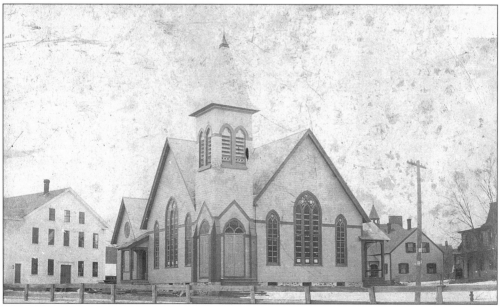

MAYNARD METHODIST CHURCH. Methodist services were carried on at Union Hall until the present Maynard Methodist Church was built and dedicated in 1895. Union Hall, in the background, is presently used as a multi-family home.

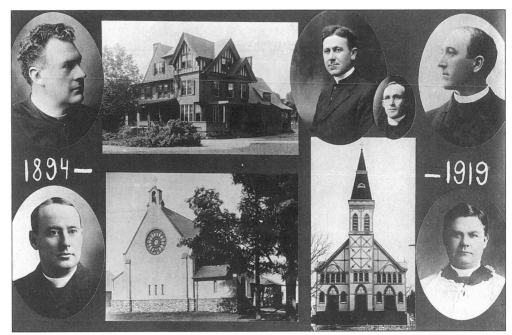

ST. BRIDGET'S PARISH. This card was prepared during the church's 25th anniversary. Pictured from left to right are as follows: (top) Fr. Browne, Fr. Crowley, Fr. Sweeney, and Fr. Crowe; (bottom) Fr. McHugh and Fr. Killilea.

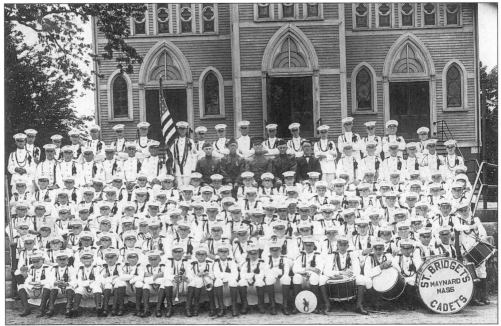

ST. BRIDGET'S CADETS. Shown here, posed in front of the church, is the Bugle, Fife, & Drum Corps made up of St. Bridget's cadets. Shown in middle are the cadet's leaders. From left to right are as follows: Sergeant William C. Coughlin (bugles), Captain Harold V. Sheridan (drilling), Major Rev. Charles A. Donahue, Sergeant John J. Gallagher (Fifes), and Frank C. Sheridan (drums).

Nine
SPORTS

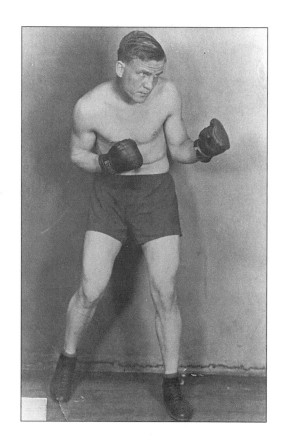

EINO "BONESY" NYHOLM. Bonesy was the Golden Glove champion in the 160-pound class in 1932. He later became a very popular Maynard police officer.

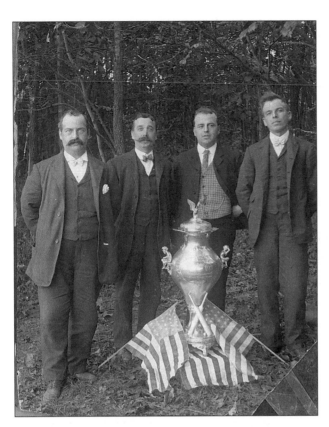

MAYNARD CRICKET CLUB CHAMPIONS. Standing behind their trophy are, from left to right, Ben Hooper, Alfred Billett, Thomas Wright, and Marsden Waterhouse.

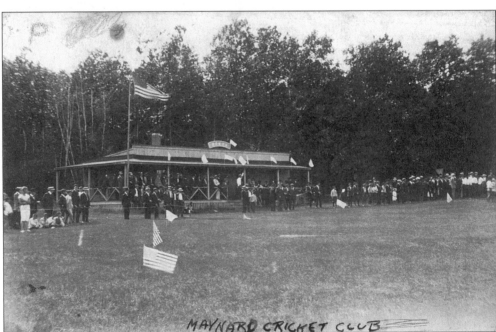

CRICKET CLUB GROUNDS. Everyone is ready for the game to start at the Maynard Cricket Club. The club grounds are now the site of the Green Meadow School.

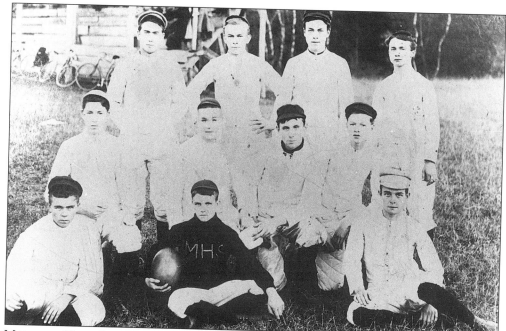

MAYNARD HIGH SCHOOL FOOTBALL TEAM, 1897. Shown in their uniforms are, from left to right and front to back, as follows: William Maley, Everett Wilson, Terrance Brady, Walter Davis, John Lawton, Chris Wilson, Arthur Drew, Louis Johnson, Wilkie Crossley, John Veitch, and Joe Gately.

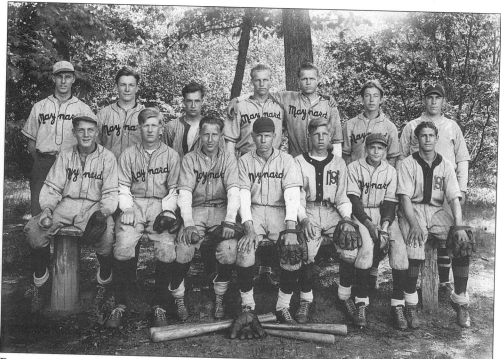

BASEBALL TEAM. The Maynard High School Baseball Team is shown here in the 1920s.

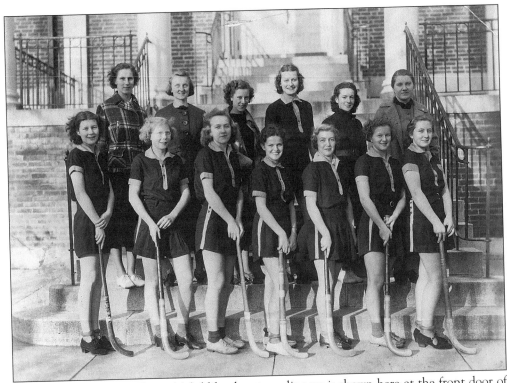

FIELD HOCKEY TEAM. The girls' field hockey team line up is shown here at the front door of Maynard High School in 1937.

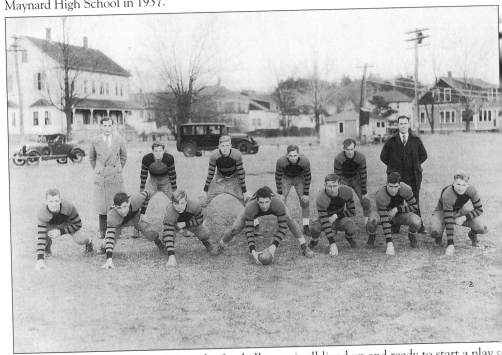

MAYNARD FOOTBALL TEAM. Here, the football team is all lined up and ready to start a play a Crowe Park. The old Garfield School is seen in the background on Sudbury Street.

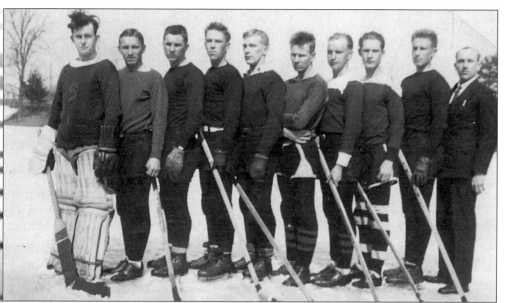

1934 HOCKEY TEAM. This lean and mean team consisted of the following, from left to right: Lawrence DeColl (Sudbury), Eugene Jokisarri, Toiro R. Atto, Arne Ollila, Osko Sulkala, Ahti Jokisarri, H. Rudolph Pirkola, George Carbary, Leonard Ollila, and Adolph Chysus (manager).

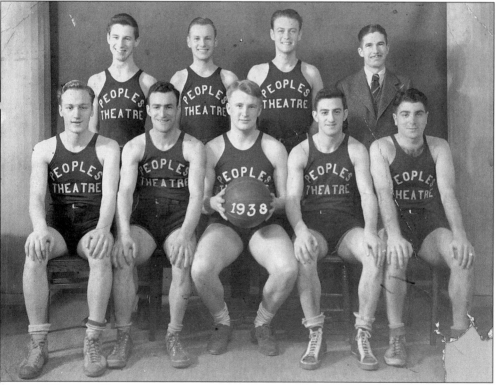

PEOPLES THEATER BASKETBALL TEAM. The 1938 team was made up of the following people, from left to right: (front row) unidentified, Joe Columbo, unidentified, Lou Columbo, and Dom Mariani; (rear row) unidentified, unidentified, unidentified, and Burton Coughlan (manager).

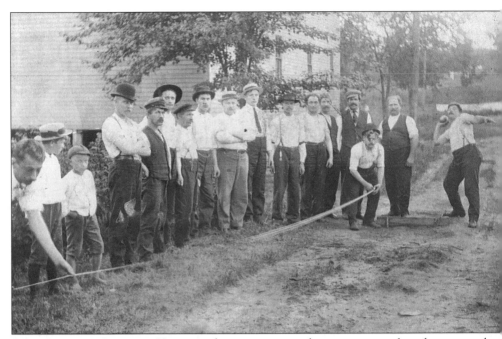

SHOT-PUTTING CONTEST. Here, people are getting ready to measure a shot throw at a shot-putting contest, which was part of the Finnish Summer festival.

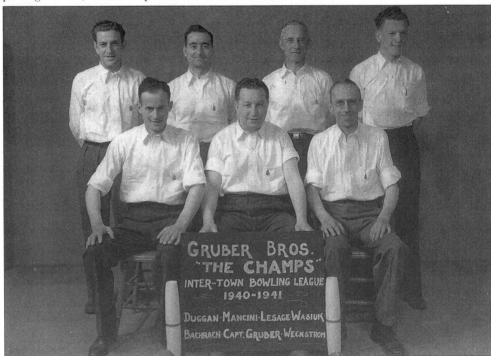

THE BOWLING CHAMPS. The Gruber Bros., champs of the Inter-Town Bowling League, are all smiles. The league was active from 1940 to 1941. From left to right are as follows: (front row) Bachrach, Captain Gruber, and Weckstrom; (back row) Duggan, Mancini, Lesage, and Wasiuk. (GRUBER.)

110

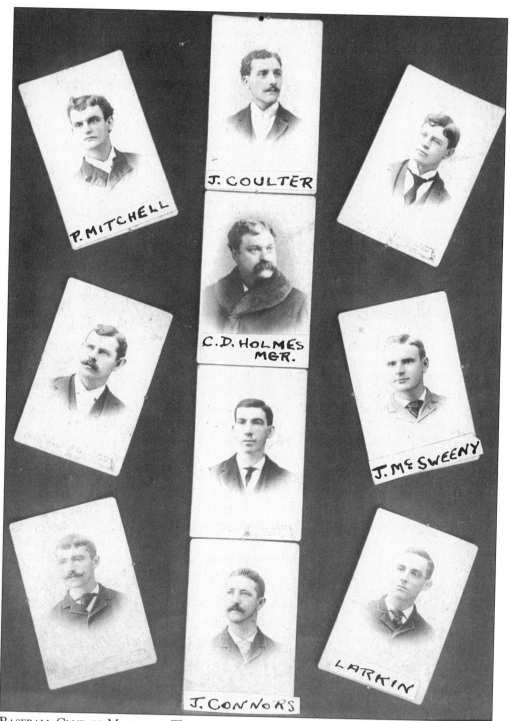

Baseball Club of Maynard. This is one of the earliest teams in town. Charles D. Holmes was the manager.

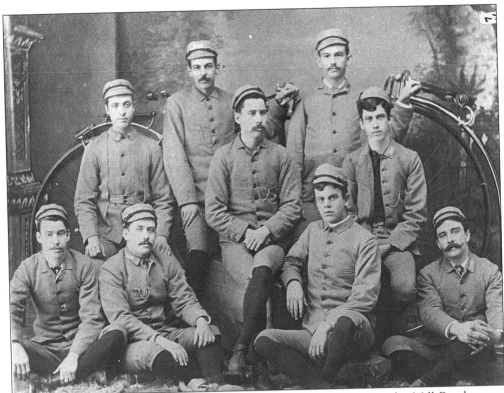

MAYNARD BICYCLE CLUB. This picture was taken about 1896 on Powder Mill Road, across from where Howard Boeske lives. Tim Nevins, one of the club members, had a bicycle shop where the Fine Arts Theatre now stands. Other members included Fred Binns, John Denniston, Thomas Denniston, Robert Denniston, and Dennis Spain.

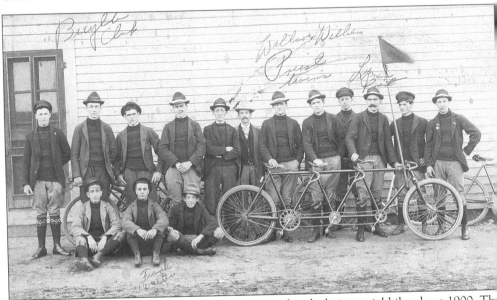

BICYCLE CLUB. The Maynard Bicycle Club was posed with their special bike about 1900. The Priest brothers were famous for their stunts on the three-passenger model shown.

Ten
POTPOURRI

FLOOD'S BARN. Flood's barn was located on Harriman Court, later known as Pastime Hall. It was built by George Flood shortly after the Civil War and used for many years as a livery stable. It was remodeled in 1919 by "C.C." Murray and named Pastime Hall. It was also called, irreverently, the "Bucket of Blood." The barn was destroyed by fire on Sunday, February 26, 1967.

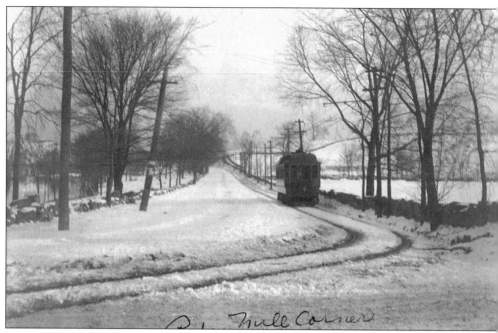

WINTER 1906. Powder Mill Road and Waltham provide a backdrop for a Concord, Maynard & Hudson Street Railway trolley that is about to make a turn onto Summer Street on its return trip from Concord and Westvale (West Concord).

WALTHAM STREET HALL. This hall was built in 1923 by the Maynard Finnish Worker's Federation. It was destroyed by an early morning fire on Saturday, April 30, 1932.

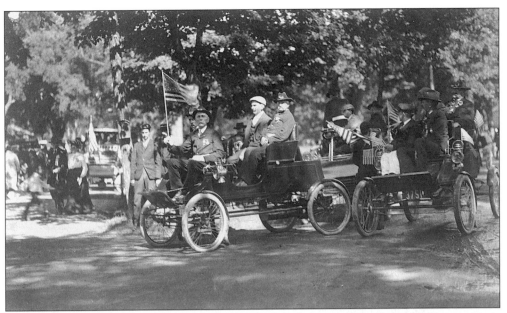

GAR at the Cemetery. This photo shows the Grand Army of the Republic Veterans tour around the Glenwood Cemetery in their motorized vehicles on Memorial Day. The Town of Maynard and various veterans' groups laid out over 2,000 markers indicating the graves of veterans of former wars.

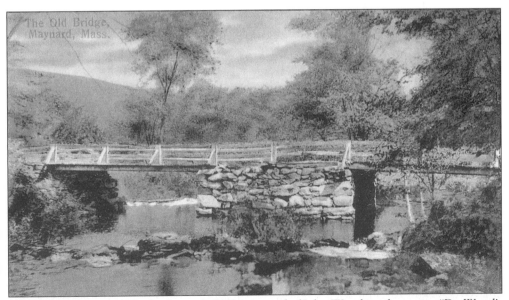

Dr. Wood's Bridge. The bridge near the homestead of John Wood was known as "Dr. Wood's Bridge" (now Russell Bridge). In order to cross the river, one crossed here or at the next bridge, which was the Old North Bridge in Concord.

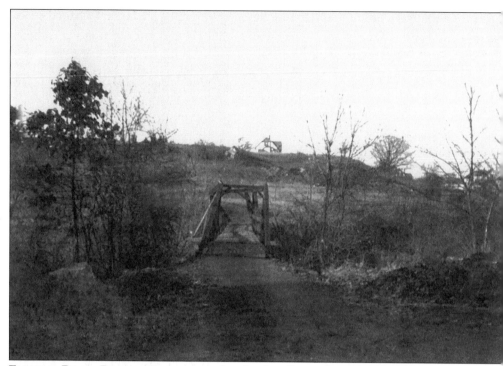

FLORIDA ROAD BRIDGE. Every time the Assabet River flooded, the old wooden narrow bridge on Florida Road washed away. Finally, in 1915, the bridge was replaced with the present cement bridge.

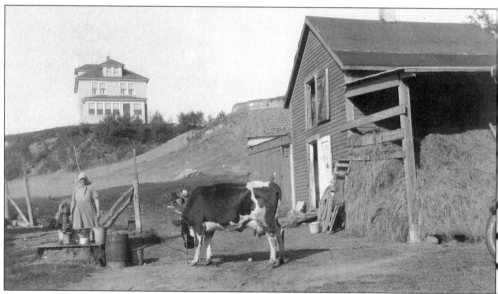

FLORIDA ROAD FARM. The Sarvela farm is located at 18 Florida Road. The farm processed and sold milk at the site. The house in the background is on upper Beacon Street. (SARVELA.)

JULY 4TH BONFIRE. On Ben Smith's Hill (Summer Hill), the bonfire was the start of a gala Fourth of July celebration. This was followed by parades, picnics, and fireworks at the end the day.

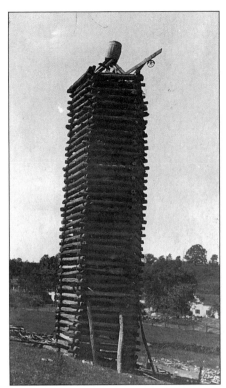

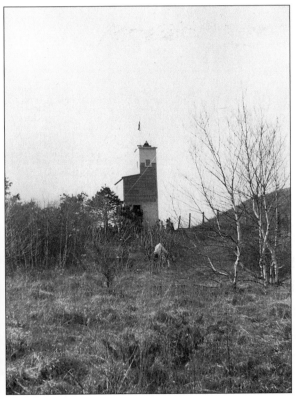

OBSERVATION TOWER. The Observation Tower on Summer Hill was manned 24 hours a day during WWII by local people. The tower was taken over by the Army when the nearby ammunition depot was established.

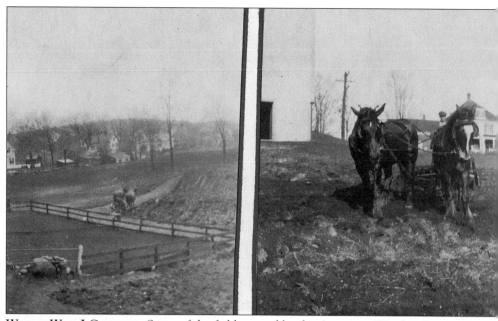

World War I Gardens. Some of the fields owned by the American Woolen Company were plowed for war vegetable gardens. These fields, off Thompson Street, are the present site of the mill parking lot, formerly called the hay field.

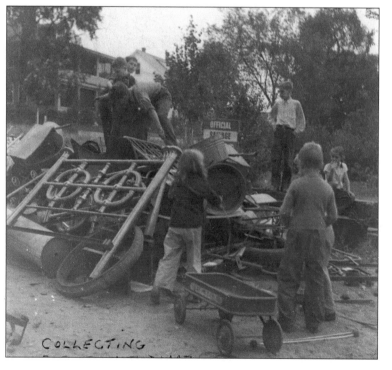

COLLECTING

Collecting Scrap. As a patriotic activity during WWII, schoolchildren would bring scrap metal to their school, where it was put in a big pile to be packed up later and sent to factories, where it was melted down and used to make war supplies for the fighting men. Alice (Hanson) Pilifant is pulling the wagon.

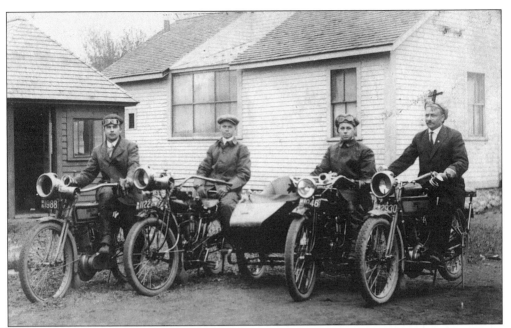

MOTORCYCLE. The motorcycle was a very popular means of transportation. Shown here, from left to right, are Frank Ketola, Waino Williams, Alfred Hendrickson (with sidecar), and Arvid Blad, a local photographer.

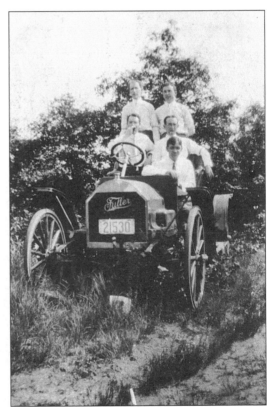

SUNDAY EXCURSION. Bill Sully, Pat Murphy, Jack Keegan, Jim Hilferty, and Jim Mahony brave the elements and primitive roads. They are seen here in the early 1900s in their Fuller automobile.

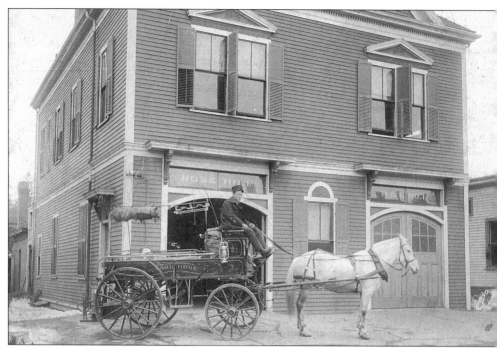

FIRST FIRE STATION ON NASON STREET. A fire-hose wagon, with its horse, stands in front of the fire station built in 1892 (now the site of The Paper Store). Tony Collins is the driver of the hose wagon. Note the old town lockup at the extreme left rear of the picture.

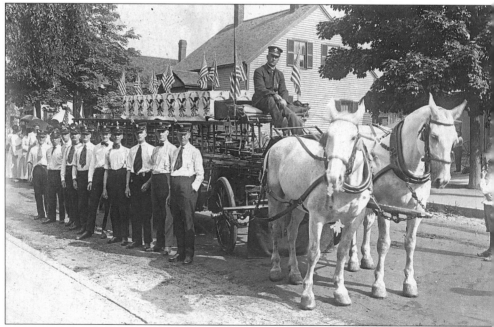

HOOK AND LADDER COMPANY. The Maynard Fire Department Hook & Ladder Company get ready to show off in a parade in 1919. Bill Quinn is the driver of the team of horses. The firemen are, from left to right, as follows: unidentified, unidentified, Arthur White, Gilly O'Donnell, Jack Maley, Albert Murphy, Bill Carney, Jack Croft, unidentified, and Jack Lawton.

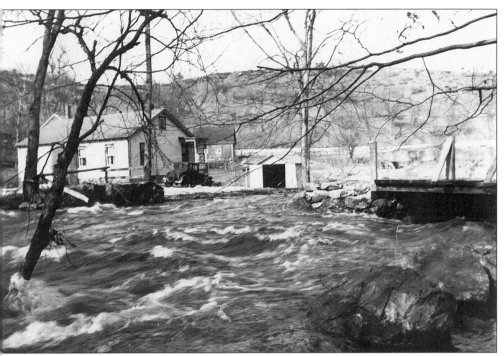

FLOOD WATERS. During the flood of March 13, 1936, the wooden bridge at Mill Street was washed out. Summer Hill is seen in the background.

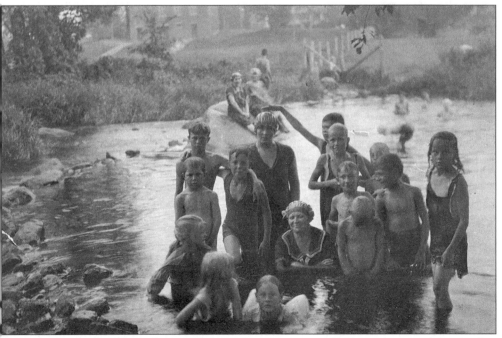

YE OLDE SWIMMING HOLE. Located behind the present town hall is a section of the Assabet River called the "Rockies." (SARVELA.)

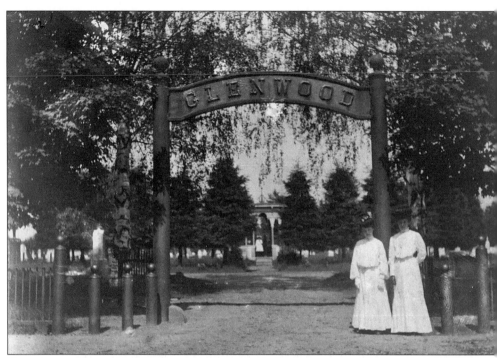

GLENWOOD CEMETERY. The original iron gate at the entrance to Glenwood Cemetery was gift from Mrs. Litchfield. The gate was replaced by a granite arch in 1915. The summerhouse i the background was destroyed by the 1938 hurricane.

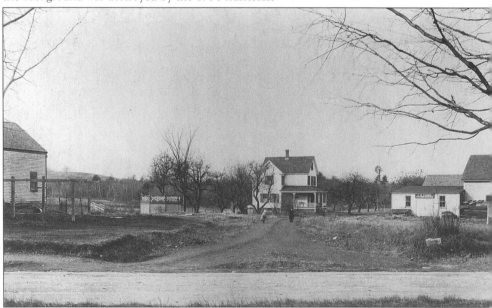

BANDSTAND LOCATION. A bandstand, located at the corner of Main and Walnut Street, wa donated in 1905 by Abel Haynes. That bandstand was used for several years by the Maynar Brass Band. About 1915, a dispute developed between the Maynard Brass Band and the Finnis Imatra Band, who wanted to use it on occasion. This resulted in the bandstand being remove to the rear of a home on Acton Street, where it deteriorated.

OLD WELL. Pictured here is the old water well on Fowler property, located on Concord Street. Previous to the town water system in 1889, there were several wells about the town where the people could get water. One was near the center of the town where the mill water boys went; one was near the Methodist church corner; and others were similarly placed around town. This well is the last of them, but it is no longer used by the public.

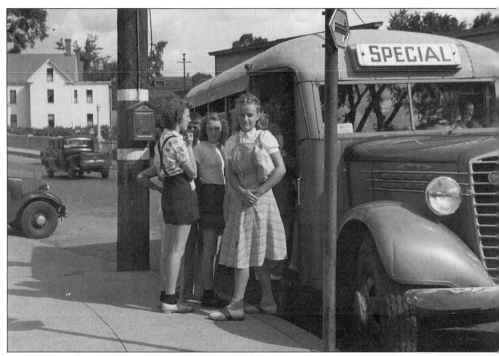

SCHOOL BUS. Maynard had only one school bus, and you had to live on the outskirts of town for it to service you. Mr. White was the owner and driver, and all grades were picked up on the same run.

BANDSTAND, ARARAT CLUB. Shown here are the remains of the old bandstand at the Ararat Club (also called Vose's before it was torn down in January 1980). Digital Equipment was the owner of this area at that time.

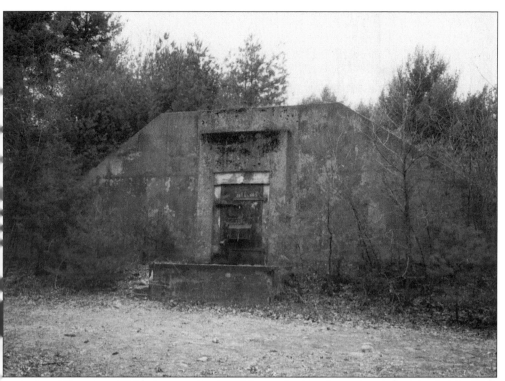

BUNKERS. There are 32 bunkers on land in Maynard taken by eminent domain by the U.S. Government in 1942. They were used to store ammunition to defend Boston during WWII. They were made of concrete, covered with earth, and connected by a rail system.

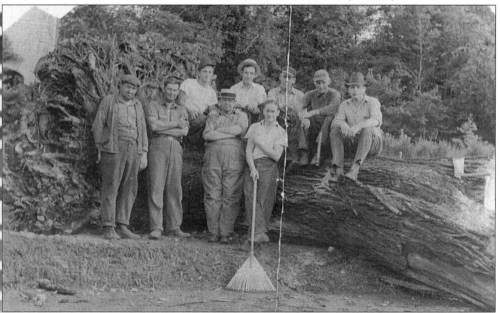

HURRICANE CLEANUP IN 1938. The work crew at Glenwood Cemetery is seen here cleaning up a large tree that fell during the 1938 hurricane. This hurricane was one of the worst in this century for New England.

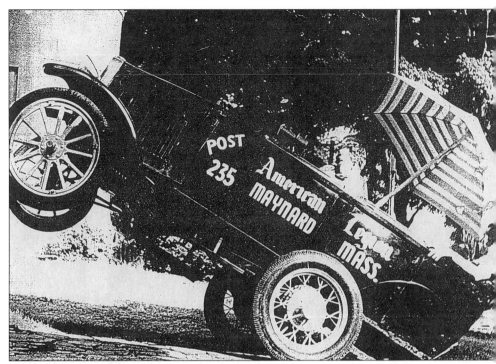

LEAPING LENA. This tipsy car, the pride and joy of the Frank J. Demars American Legion Po[?] 235 in Maynard, was often included in parades. Gill Greenaway was its driver. The passenger i[?] the rear seat is American Legion Post Commander, Thomas Smith. The Legion Post was nam[?] after Frank J. Demars, the first Maynard casualty in World War I.

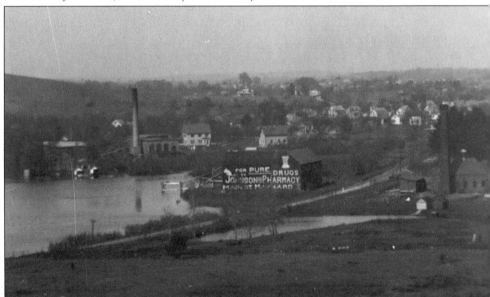

BENT ICEHOUSE The James R. Bent Icehouse, located on the banks of the Assabet River, [?] pictured here. The Boston & Maine Railroad to Marlboro runs through the field in front of t[?] icehouse. The pumping station is shown on the right, and the powerhouse and barn for t[?] CM&H Street Railway is on the left of the picture.

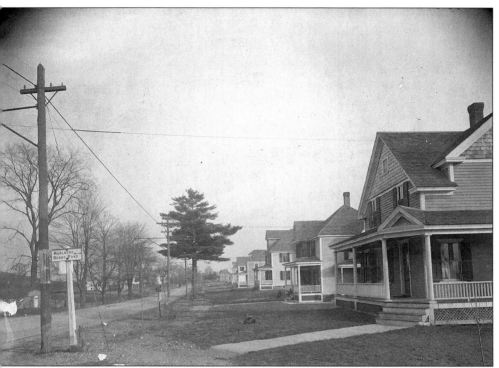

GREAT ROAD. The Great Road is shown here, as seen from the Stow town line. Behind the post, in the left-hand corner, is Ben Smith's Tomb (later moved).

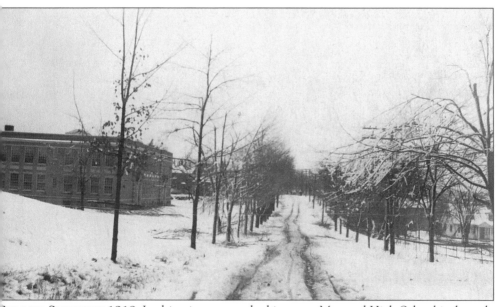

SUMMER STREET IN 1918. In this winter scene looking east, Maynard High School is the only school built at that time. The Emerson Junior High, now called the Fowler School, and the George Washington Auditorium were built in the 1920s.

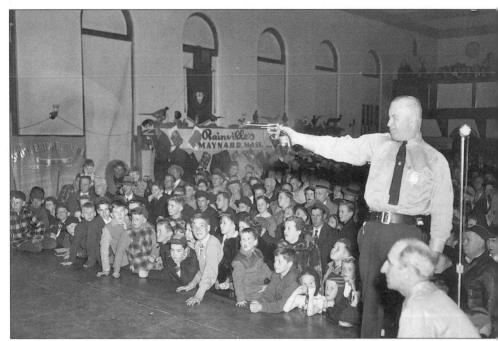

SHOOTING EXHIBITION. This photo shows Maynard Rod and Gun Club live shootir exhibition on the stage of the George Washington Auditorium. It was one of the mar sportsman shows held there around 1950. (Rod & Gun.)

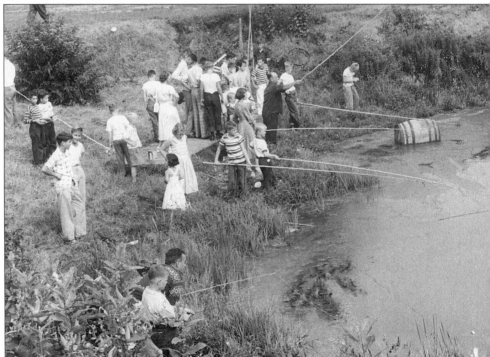

FISHING DERBY. This derby is held as an annual event in the spring at the Maynard Rod ar Gun Club. (Rod & Gun.)